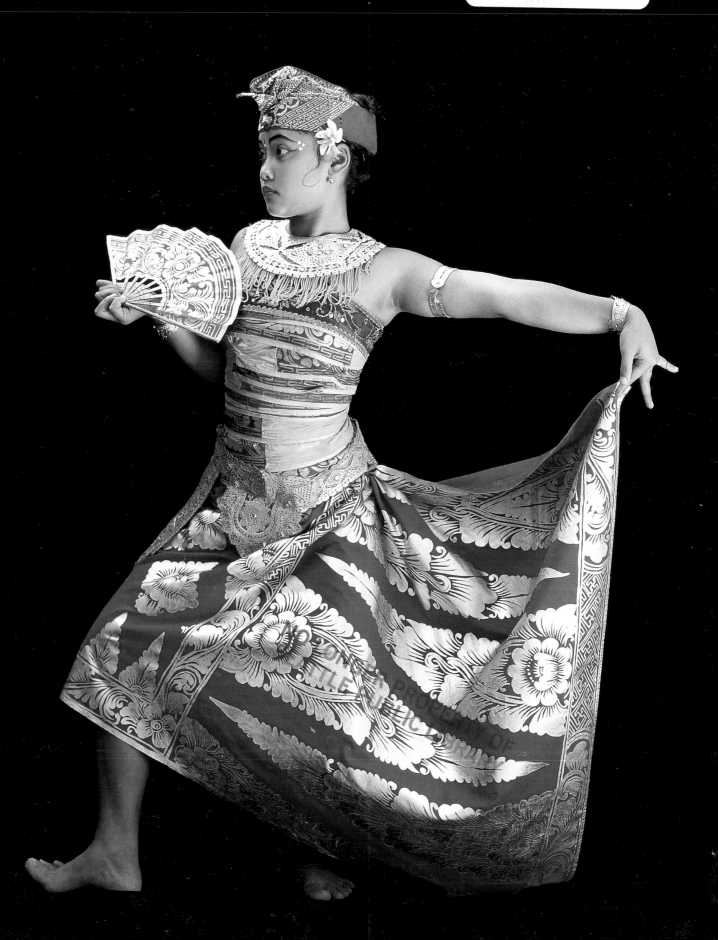

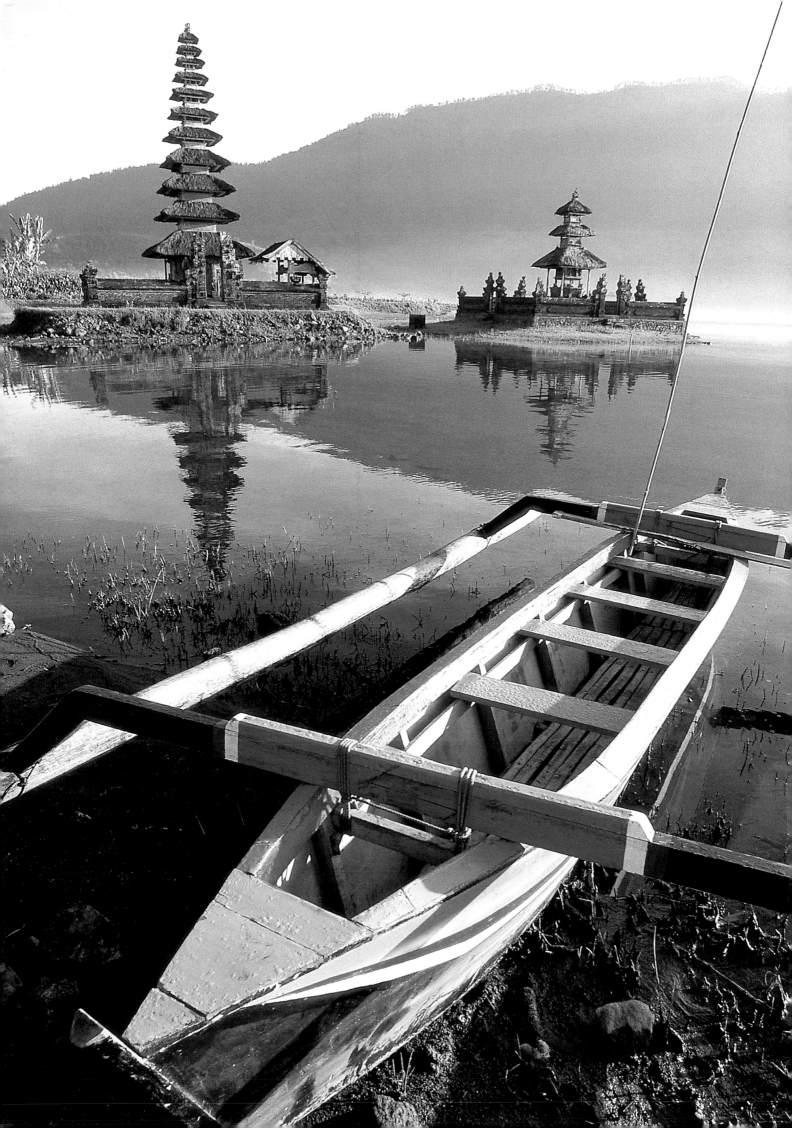

Bali

the legendary isle

photography by **R. Ian Lloyd**

text by **Patrick R. Booz**

TUTTLE Publishing

Tokyo | Rutland, Vermont | Singapore

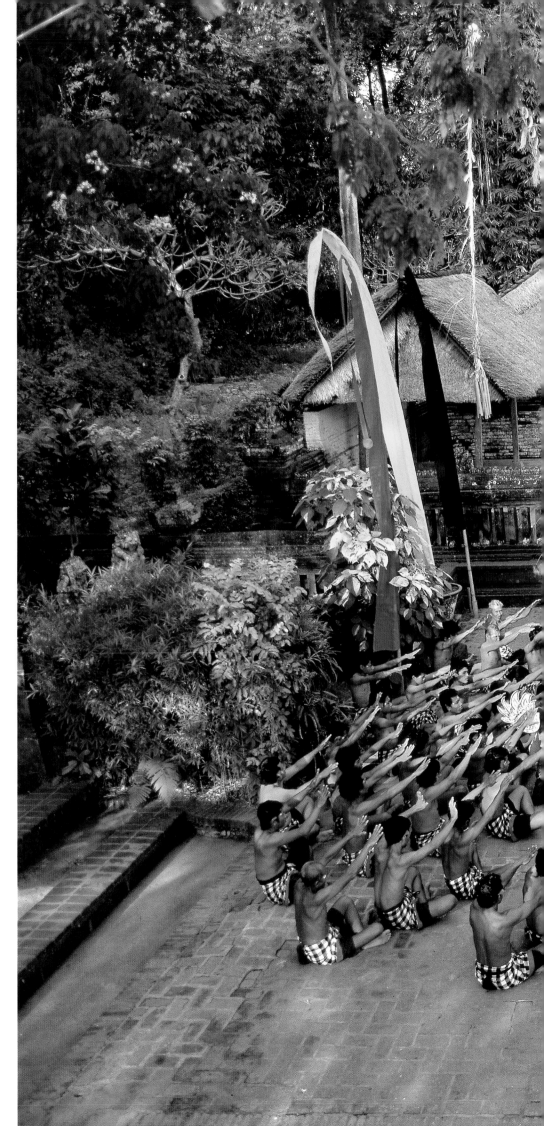

Published by Tuttle Publishing, an imprint of
Periplus Editions (HK) Ltd.

www.tuttlepublishing.com

ISBN 978-0-8048-4397-3

16 15 14 13 4 3 2 1 1309CP

This volume is a revised and expanded edition
of *Exciting Bali* (962-593-210-0) and *Bali: A Travel
Portrait* (962-593-082-5).

Printed in Singapore

Distributors

Asia Pacific Berkeley Books Pte Ltd
61 Tai Seng Avenue #02-12, Singapore 534167
Tel: (65) 6280 1330; Fax (65) 6280 6290
inquiries@periplus.com.sg
www.periplus.com

Indonesia PT Java Books Indonesia
Kawasan Industri Pulogadung
Jl. Rawa Gelam IV No.9, Jakarta 13930
Tel: (62) 21 4682 1088; Fax: (62) 21 461 0206
cm@periplus.co.id
www.periplus.com

Japan Tuttle Publishing
Yaekari Building 3rd Floor, 5-4-12 Osaki
Shinagawa-ku, Tokyo 141 0032
Tel: (81) 3 5437 0171; Fax: (81) 3 5437 0755
sales@tuttle.co.jp
www.tuttle.co.jp

North America, Latin America & Europe
Tuttle Publishing
364 Innovation Drive, North Clarendon
VT 05759-9436
Tel: 1 (802) 773 8930; Fax: 1 (802) 773 6993
info@tuttlepublishing.com
www.tuttlepublishing.com

Page 1: A *kebyar duduk* dancer strikes a stylized
dance position. This dance was first choreographed
and performed in the 1930s.

Page 2: An outrigger canoe rests on the shore of
Lake Bratan in front of the important Pura Ulun
Danu Bratan temple complex.

Right: The *kecak* dance is a spectacular sight as it
is performed by a large troupe of at least 50 men
chanting in rhythm.

Pages 6–7: Terraced *sawah* (rice fields) are found
throughout Bali, wherever water is available from
spring-fed streams.

Pages 8–9: Surfboards for rent on Kuta beach.
An American named Robert Koke is credited with
introducing the sport to Bali in the late 1930s.

Pages 10–11: The Amandari resort, located just
outside Ubud, was designed along the lines of a
Balinese village. The open-air lobby was designed
after a village meeting place, or *wantilan*.

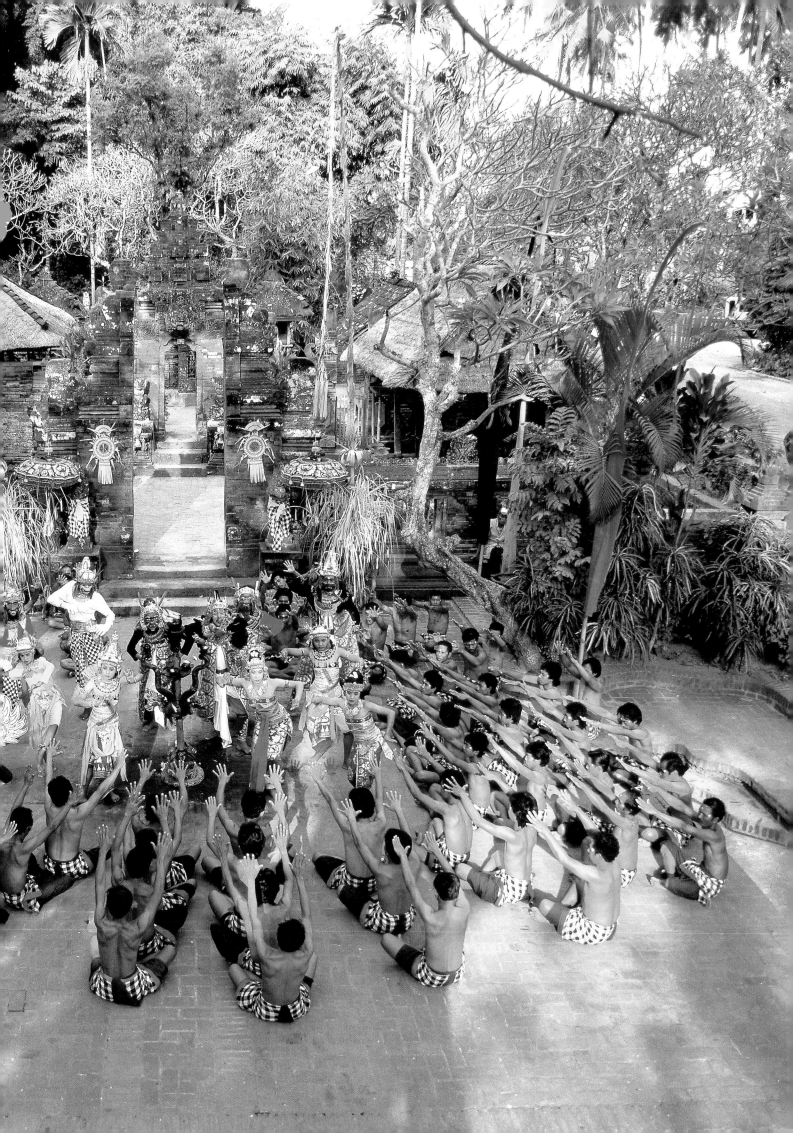

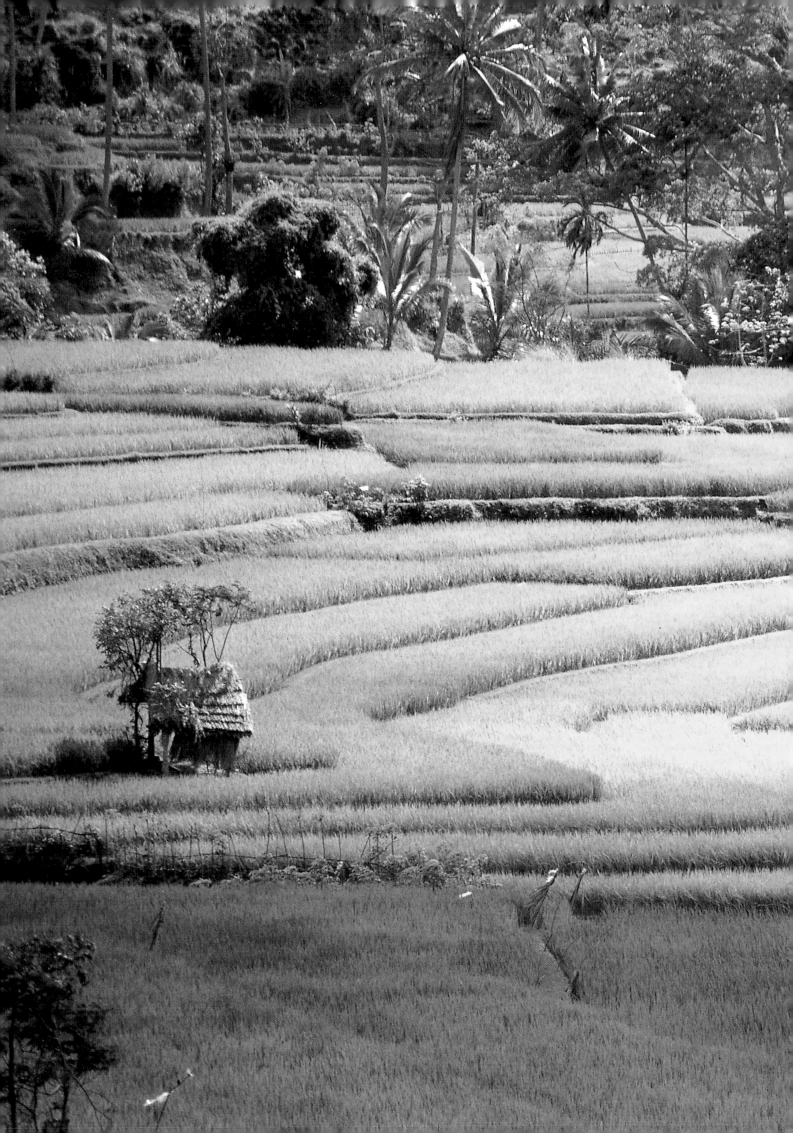

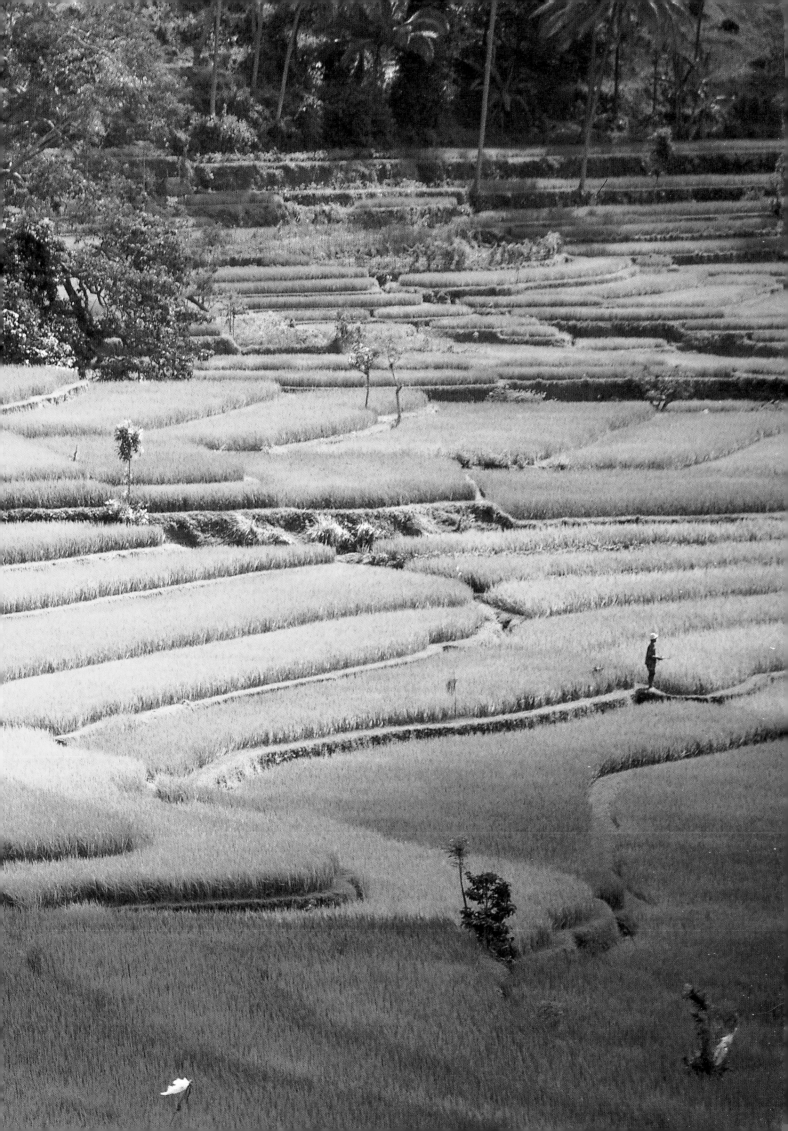

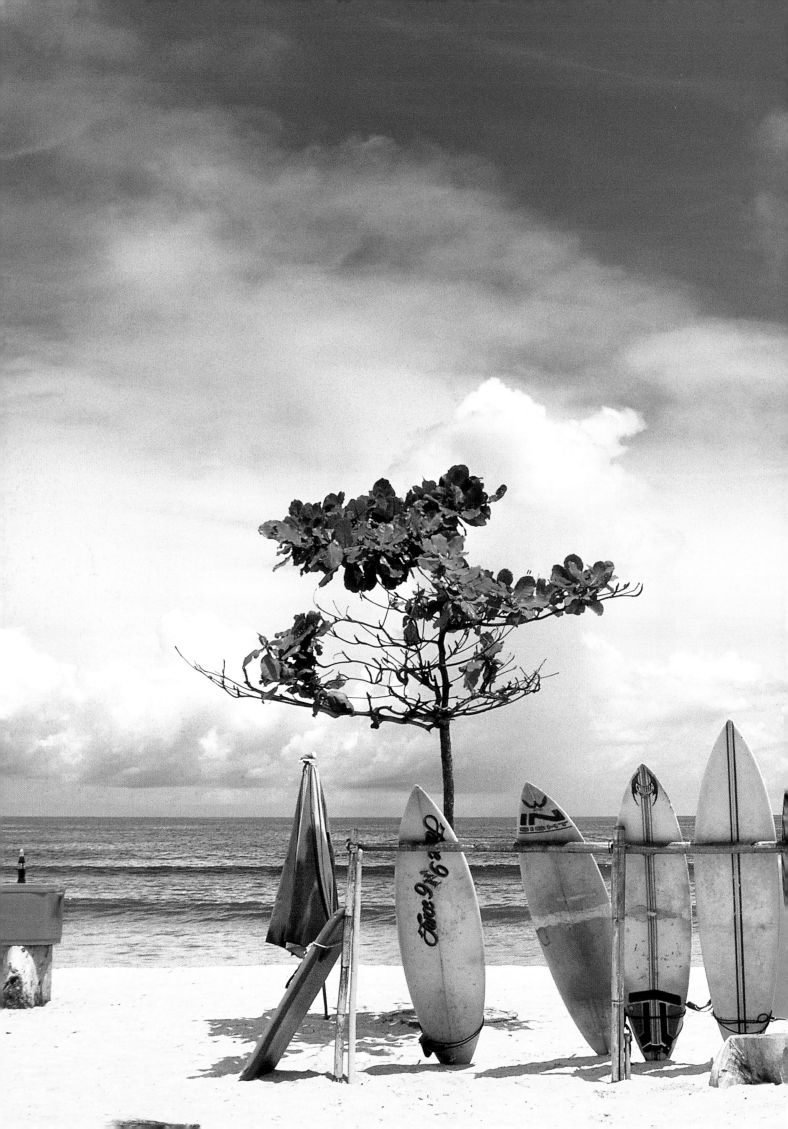

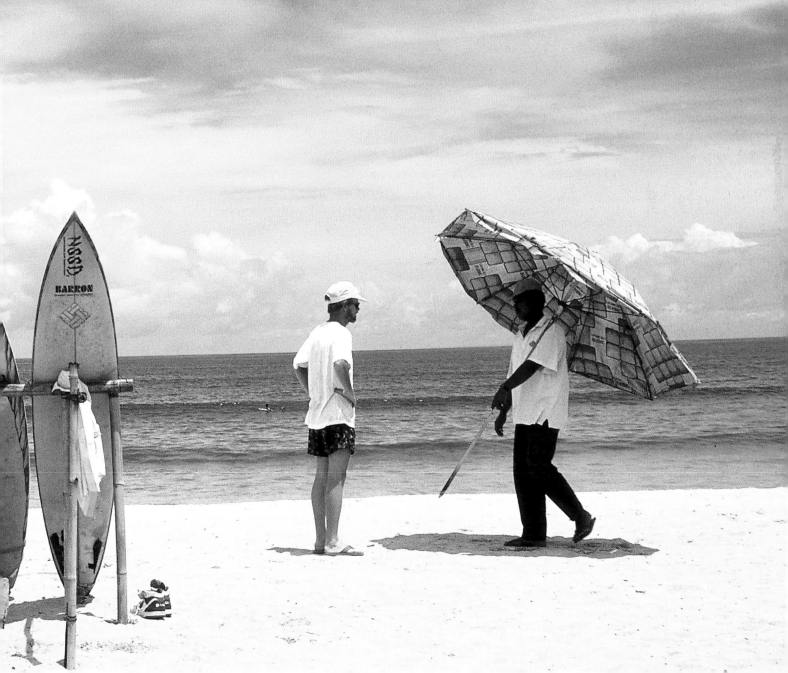

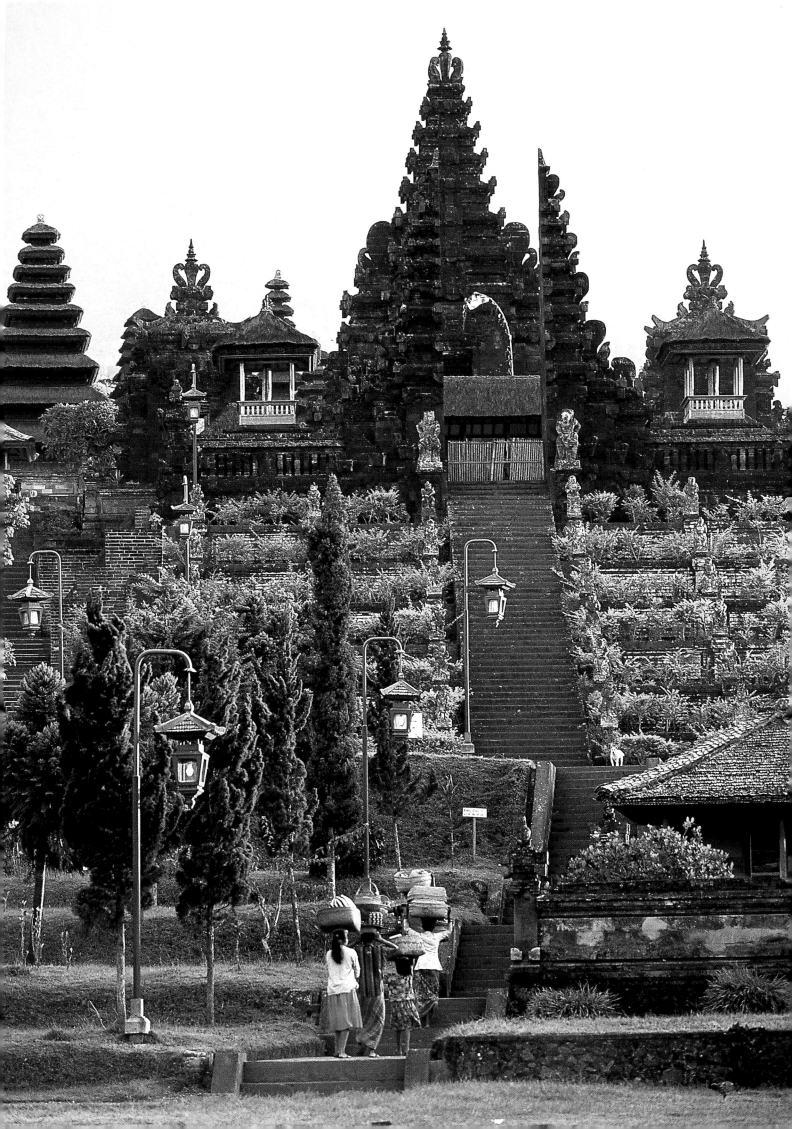

An Island Unto Itself

Opposite: The Pura Besakih temple complex is over half a mile (one kilometer) long and consists of 22 temples.

Below: Solemnity marks the beginning of the tooth filing ceremony which is usually conducted when the young approach puberty.

The island of Bali is just one of the thousands of islands in the Malay Archipelago—that great chain that straddles the equator from New Guinea to the tip of Sumatra and once, eons ago, formed a land bridge between Asia and Australia. Yet unlike the other islands, Bali has held sway in the world's imagination for most of the past century. Bali's special reputation came about for several reasons, but to the visitor its allure and fascination are clear and immediate. The island is physically beautiful and the people, lithe, graceful and full of friendliness, exude a quiet confidence.

To the Balinese, their island is the entire world. Other worlds may exist outside, but theirs is complete and whole in itself, a total provider, bountiful with all the physical and spiritual attributes important to existence. In fact the Balinese cosmos is so rich that the psychic, unseen world is constantly spilling over into the mundane. Daily life is a constant expression of the need to honor, praise and propitiate gods and nymphs, demons and witches. Hardly a day goes by without a procession or temple festival, and at night villages far and wide come alive to opera and dance-drama, accompanied by the strange, hypnotic music of gamelan percussion orchestras. To an outsider, Balinese life seems to be a continuous celebration with brief intervals for rest.

According to legend, Bali originated as a special event during the creation of the universe. Through the purity of meditation, the phenomenal world emerged, magnificently arrayed, layer upon layer, from the base of the cosmos below to the perfumed heavens above. In between, the island of Bali appeared, resting on an immense turtle afloat in a vast ocean.

The scientific explanation of the island's birth and development is a wonderful story as well. Once connected to the massive Asiatic mainland, Bali became an island after the melting of the polar ice caps nearly 120 million years ago. Bali is considered the last outpost of mainland Asia, separated by a 1,000-foot (300-meter) deep channel from the island of Lombok to the east. This

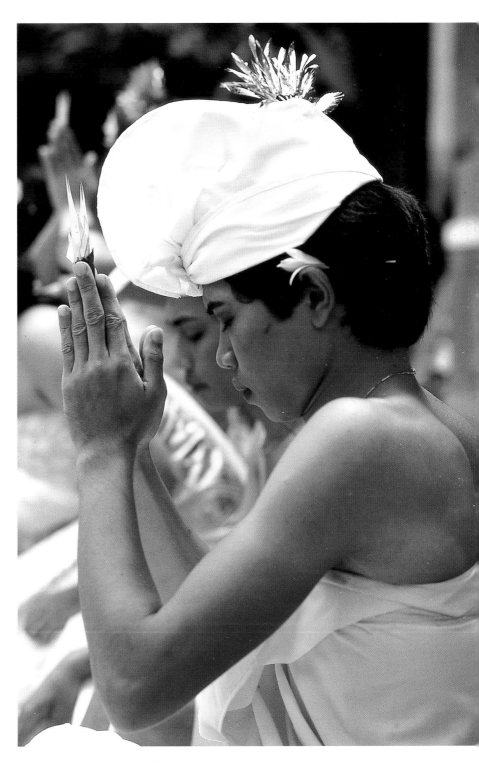

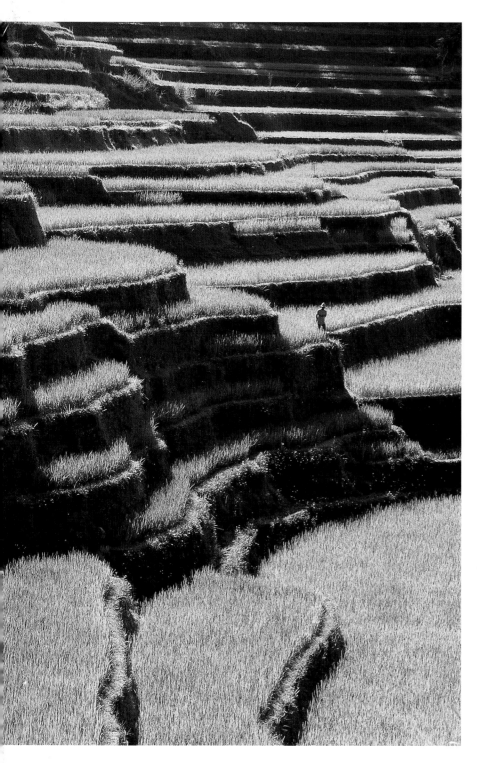

channel also represents an ecological boundary known as the Wallace Line after the 19th-century naturalist Alfred Russel Wallace. He noted that Bali has luxurious vegetation and animals found on the Asian mainland such as elephants, tigers, monkeys and wild cattle, while Lombok and the islands to the east suggest an affiliation with Australia and not Asia. Here , east of the Wallace Line, the climate is more arid and the vegetation thorny and scrub-like. The animals include marsupials, the world's largest lizards, parrots and cockatoos, and relatively few insect species.

Bali is just over 2,000 square miles (5,181 square kilometers) in area, barely one-quarter the size of Wales, and densely populated with nearly three million inhabitants. Its tropical richness and the ingenious use of terraced rice fields allow the land to support such overcrowding. Elaborate systems of irrigation bring water down from the high volcanoes to the shimmering emerald-green fields found in most corners of the island. Rice is the most important food in Bali; the crop is the source of life and wealth and is recognized as a gift from the gods. According to legend, rice first appeared on Bali when the male God of Water raped Mother Earth to beget rice. Wet-rice farming has been practised on Bali for well over 1,000 years, and today's amazing contoured landscape is the heritage of 50 generations of farmers.

The need to tend the rice and care for the fields led to the rise of the *desa*, or village, the chief social unit in Bali. It is much more than just a village, however, it is community, parish and focal point of all life for the Balinese. Cozy and safe within a lush grove, surrounded by walls and bountiful trees—coconut, banana, papaya, breadfruit—the *desa* functions to maintain the cosmic balance and harmony within the area of its jurisdiction, thus assuring the wellbeing of all. Every *desa*, and there are hundreds of them spread throughout the island, is thus seen to be fulfilling its obligation to gods and men.

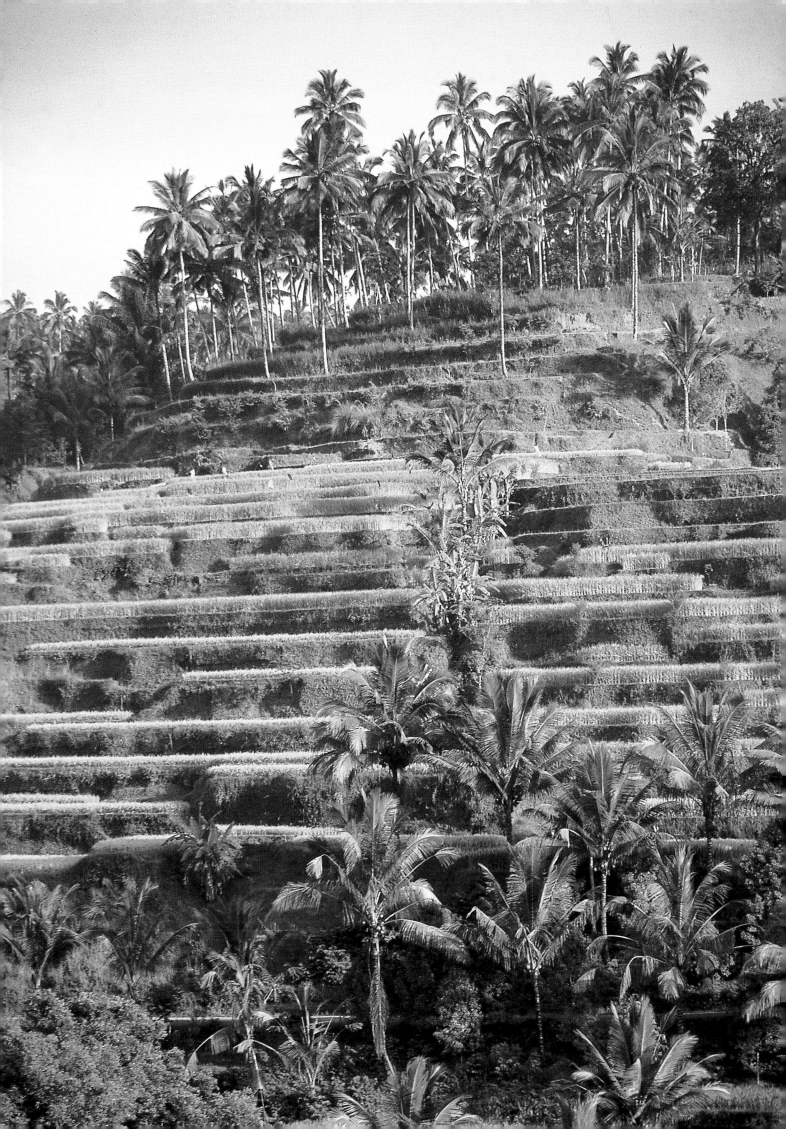

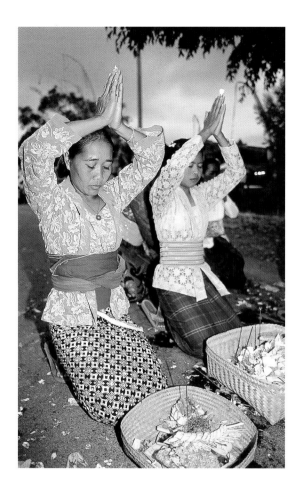

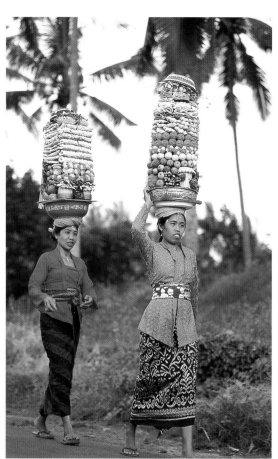

Balinese women present offerings at a temple festival (left). Temple festivals (opposite) and rituals are an integral part of Balinese life. Some rituals are only held on holy days such as Galungan. Other rituals, such as the tooth filing ceremony, can be organized by anyone who needs them. Balinese rituals are grouped into five ritual categories, or *panca yadnya*. While each rite has a different meaning, their purpose is the same—to cleanse objects or people and foster a sense of wellbeing and community.

Bali has often been called the "Land of a thousand Temples". Hindu temples, from small shrines in the rice fields to sprawling complexes belonging to large towns, are certainly the most important institution on the island, and they can be seen everywhere. By the sea, on desolate promontories, in caves, on the highest mountains, even entangled in the roots of banyan trees, large and small temples appear as a natural component to the island's geography.

From earliest times, before the overwhelming influence of Hindu temple building arrived from Java a thousand years ago, there have been plots of consecrated ground, where altars, cairns, and stone enclosures marked a kind of primitive temple. Such temples still can be seen in the eastern part of the island where isolated villages protected these old forms.

Every Balinese community has at least three main temples: the foundation temple of the original village, often hundreds of years old, a town temple for communal celebrations and the temple of the dead for the gods associated with death and cremation. The reason for this division is to maintain a balance between the innumerable contending forces of the invisible world, which to the Balinese has a trenchant reality.

The language of Bali is a member of the Austronesian family, a vast group of languages that extends from Hawaii and New Zealand in the east to Taiwan, across the Pacific to the islands of Indonesia and Madagascar in the west. Balinese is more closely related to the languages and dialects of its eastern neighbors than to Javanese, the tongue spoken to the west by nearly 100 million people. Nevertheless, Old Javanese and Sanskrit have greatly influenced Bali's vocabulary, much as Latin and French have contributed to English.

The outstanding characteristic of Balinese is the use of "vocabularies of courtesy", a linguistic phenomenon that developed with the introduction of Hindu caste hierarchies. There are in fact three special vocabularies within the language. Common speech is used between friends and intimates and employed when speaking to a person of lower social standing. The polite form is spoken to strangers (before their rank is known) and to superiors. The deferential form is used by commoners when speaking to high caste persons, priests and other important people. Misuse of these three vocabularies, whether through ignorance or arrogance, is a serious faux pas, and in certain extreme, but rare cases could result in a court case and punishment.

In spite of these special vocabularies and the traditional, strict adherence to social rank through caste, interaction between people is remarkably frank and easygoing. There is a universal sense of

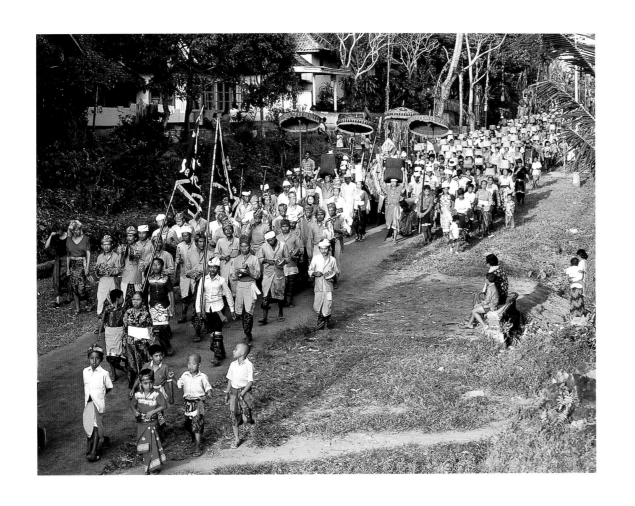

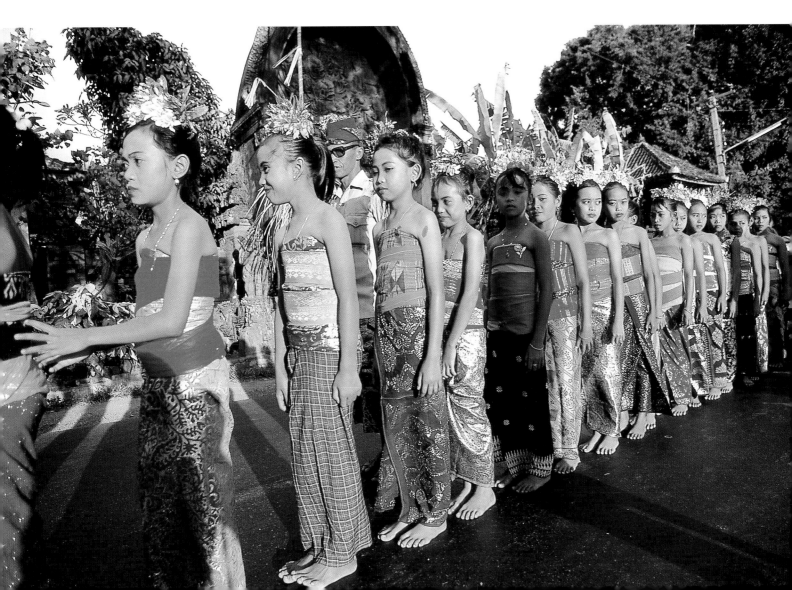

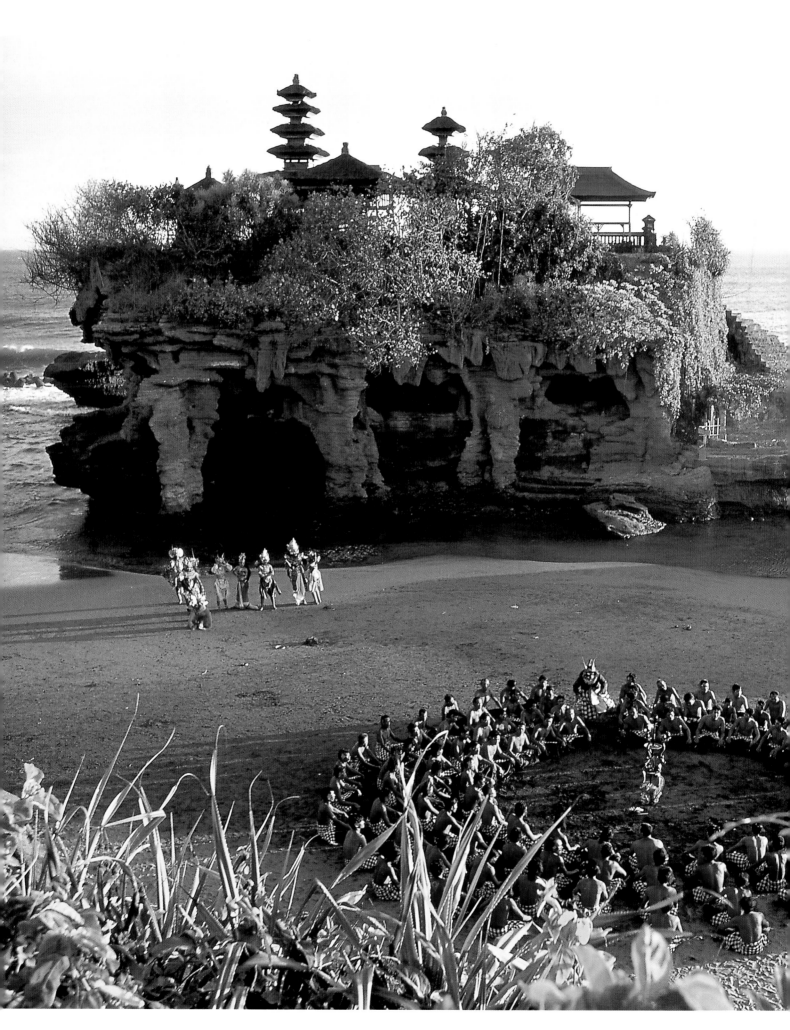

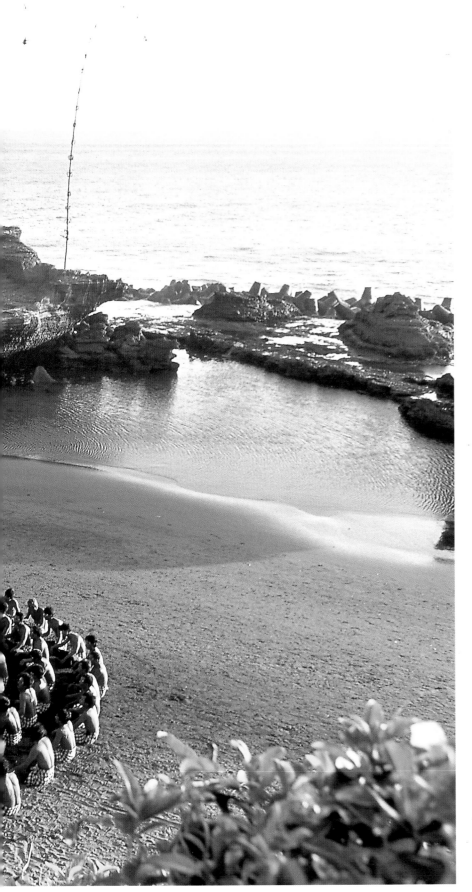

A *kecak* troupe performs in front of Pura Tanah Lot. Built atop a rocky outcropping just off the coast of Tabanan, Tanah Lot is accessible only during low tide. The temple is one of the six most holy temples (*sad kahyangan*) in Bali.

happiness and gentleness among the Balinese, and their polite ways and deference are thoroughly natural and unaffected.

Art and ritual are the living breath of the Balinese. There have been times and places in the West, in Renaissance Florence for example, where people expected beauty in their surroundings, where they talked about artists endlessly and where they appreciated high artistic standards. This has always been the way of the Balinese; nearly everyone, high or low, man or woman, young or old, is engaged and competent in an art or craft. Technically speaking the words "art" and "artist" do not exist in the Balinese language, which is perhaps a reflection of the universal involvement of Balinese with some form of aesthetic expression. Although a great painter or carver is recognized as such, and given pride of place in the community, he or she is not part of a separate class of artists, but is instead no different from a farmer, clerk or simple laborer.

Hand in hand with this casual and self-effacing attitude towards talent, where the greatest good is simply to create something beautiful for the community, the temple or the gods, is the ephemerality of Balinese art. Tropical decay is constantly at work. Wooden posts and statues are prey to insects, rain and humidity destroy paper and cloth, the sun and heat assure lovingly made offerings of palm fronds, fruit and flowers last only a day. Even stone carvings have a short life. Sandstone and lava, soft and friable, are the only materials available and, after a few years, the friezes and intricate sculptures into which they have been shaped become unrecognizable. There is a constant need to create, replace and rebuild which makes for the freshness and everlasting youthfulness of Balinese art.

The Balinese look back proudly to a glorious past of rajas, princes and heroines, times that brought them their traditions and laid the foundations for a remarkable, vibrant society. Confident in their origins and worldview, they have never suffered from stagnation and their

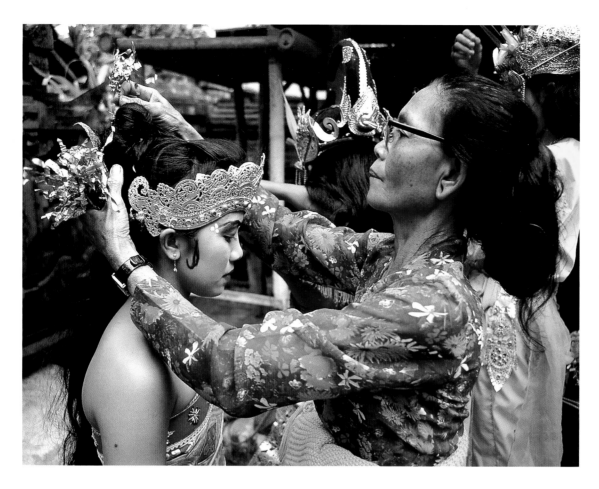

A young Balinese dancer prepares for a performance at a temple festival.

very openness to influences beyond their world has helped to create a special, eclectic mind and aesthetic. Absorption, adaptation and flux have always been a part of Balinese life, an ongoing source of creativity. Influences from Southeast Asia, India, Java, China, Europe and now even Australia and America, have touched Bali, leaving their imprint on the people and the art, but they always are transformed in a uniquely Balinese way, with zest, vigor, color and, frequently, humor. Where else but in Bali could you have an outrageous painting of anthropomorphic frogs snapping away with their cameras? Or a wall carving on an early 20th-century temple showing fat Dutchmen in an automobile?

Amidst the playfulness is a deeper, darker side to Balinese life. In various forms of expression, but usually in that of the dance-drama, the Balinese express the deepest concerns of their collective subconscious. These have to do with struggles between good and evil, strong and weak, clean and unclean.

Dance and drama are a united form in Bali and do not occupy separate spheres as in the West. They grew out of a religious tradition and in most cases still have religious importance. Entertainment of the deity with dance and music is as natural to the Balinese as the presentation of offerings.

Dance in Bali also brings delight to people and fulfills many needs and purposes. The *baris* dance, for example, is full of martial expression and gives vent to manly virtues and preoccupations. The *legong*, probably Bali's finest dance, is highly refined and feminine, and appreciated on a purely aesthetic level. The *kebyar* is a solo performance of brilliant showmanship. Fun and flirtation are the soul of the *joged* and *janger*, and a wide range of historical and mythic epics find expression in the *topeng* masked dramas and *wayang kulit* (shadow puppet) plays.

Dances that involve trance, however, lie at the core of the Balinese religion. Here contact is made with the unseen, and fragile humans become heroic as they enter into the world beyond. In the dance called *sangyang*, young girls bring luck and protective magic to the temple and village. They are the psychic adventurers who go over to the other side to bring back news of the gods, to convey their wishes and moods. Even death itself is approached. As intermediaries and confidants of the deities, they return and help bind together the community by sharing the experience of their contact. They reassure everyone by showing that awesome, unknown mysteries can be faced and survived.

Every young dancer is rigorously trained under the care of a special teacher, himself more than

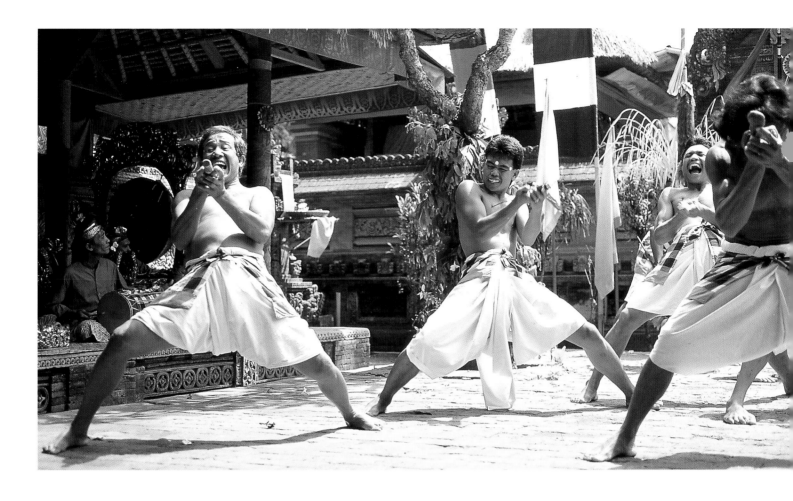

likely a once-famous performer. But the hidden stresses and unpredictability of dance training sometimes erupt into wild and frenzied displays that abandon all discipline and only permit order once exhaustion overtakes the dancers. In times of turmoil, some villages hold trance dances night after night to keep the land calm. Expressions of the deities' will, in whatever form, is seen to be a purgative and a balm.

The uses of trance can serve other ends as well. It might be "discovered" through a trance intermediary that the god in one village is the mother of a god in another. A procession of visitation must take place, and, intentionally or not, two places are brought closer together, old feuds set aside. Trance can legitimate political movements by revealing the "correctness" of a particular ideology, and it sometimes explains new developments or strange occurrences, such as natural calamities, that confound a community.

The most powerful use of trance, and the most magically dangerous dance-drama, takes the form of a titanic struggle between the forces of good and evil. Nothing short of humanity's welfare is at stake.

This is the symbolic play of Barong and Rangda, Bali's two most remarkable creatures. The Barong is a benevolent mystical beast, Lord of the Forest, who intercedes on behalf of mankind to fight disease, black magic and all forms of pollution. His adversary is the hideous Rangda, witch-widow, child-eater and Queen of Death. Barong enters first, dancing and prancing, played by two men hidden beneath a holy mask and a lion's body. Rangda then appears with a terrifying fanged mask, its flaming tongue hanging far down between two grotesque pendulous breasts. Fighting begins and the course of battle shifts from side to side. At the moment Rangda appears to win, a group of men, all entranced and wielding daggers, rush to Barong's aid. Rangda's witchcraft turns the men's blades against themselves in the fearful climax of the drama. These men in a cataleptic state engage in self-torture and only the Barong's power saves them. There is no decisive resolution to this dance-drama—only a temporary victory for the forces of good and a short-lived abeyance of wickedness. Everyone goes home exhausted and relieved, knowing there will be more music and drama, more exuberance and excitement in the days to come.

Recognition of Bali's special place in world culture arrived somewhat slowly. In the 16th century Europe's great powers came to the East Indies in search of spices and colonial footholds. Portugal and Spain were first, followed by Britain and Holland. There were certainly sightings of

A pivotal moment during the Barong dance-drama as trance dancers have their daggers turned against them by the black magic of Rangda.

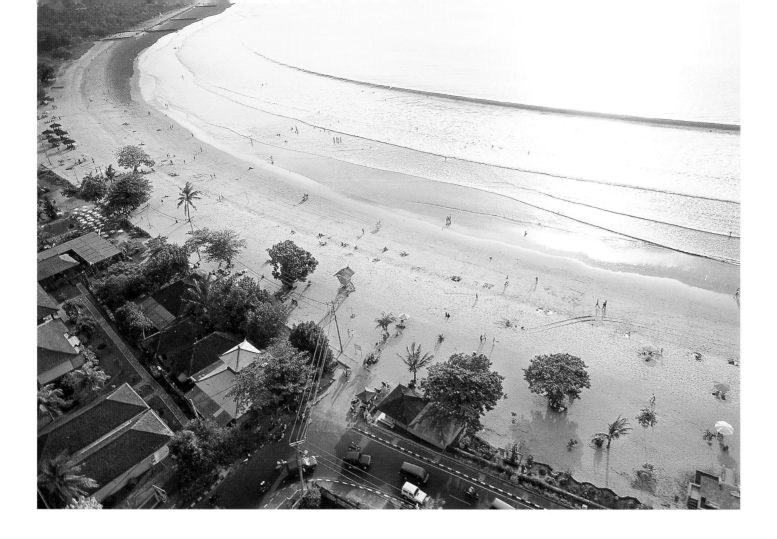

Bali by these foreigners and even a landing in 1580 by the irrepressible Sir Francis Drake but no written records of Bali were made until the final years of the 16th century. In 1597 a Dutch party came ashore and wrote the first account, though superficial, of the island. For the next one-and-a-half centuries, knowledge of Bali remained scant, with only occasional visits and commentaries by outsiders. In the mid-19th century things changed with the arrival of a profound Sanskrit scholar. That marked the beginning of serious study of Balinese culture and there followed a string of excellent, dedicated Dutch academics who have continued their work up to the present day.

But the great age of Bali's blossoming, its opening to the world, was in the 1930s. It was then that a small, influential group of Western artists, anthropologists, ethnomusicologists and novelists produced an outstanding body of work, sensitive and full of insight into Balinese life. Unfortunately among general readers the idea of Bali as Paradise developed, and this misreading was exacerbated by tour operators and cruise ships that brought tourists by the hundreds to gawp at bare-breasted maidens and take snapshots of "temple dancers." At about the same time, a series of sensationalistic films on Bali became popular in Europe and North America. *Goona-goona* was the title of one of these films.

It means "magic" in Balinese but became a slang term in New York for sex appeal.

As early as 1937, Miguel Covarrubias, a writer, keen observer and advocate of Balinese culture, predicted gloomily that the way of life "is doomed to disappear under the merciless onslaught of modern commercialism and standardization." Seven decades later, the same question remains: Is Balinese culture already ruined or will it be able to withstand the seemingly relentless onslaught of tourism? In some respects the question is moot, as such issues, vitally important to the Balinese, can only be answered by the local people themselves. For all the exotic characteristics of Balinese culture, it has one enduring and fundamental goal: balance and harmony within natural and supernatural worlds. If the people of Bali can hold fast to this goal, no external force can defeat their spirit or way of life.

The real Bali does still exist, although the quality of this reality varies from place to place. The finest and truest this intriguing island has to offer will not appear effortlessly to the casual observer, although patience, care and understanding can help reveal the magic of Bali. The pictures in this book are an affirmation, and their force and color a small souvenir, of a truly beautiful island.

Above: The Kuta and Legian beach area in southern Bali is one of the most popular destinations in Asia today.

Right: Uluwatu temple perches dramatically atop a narrow cliff that commands a spectacular view of the Indian Ocean. Tourists flock to this 11th-century temple, attracted by its stunning sunset view.

Pages 24–25: At Batuan, the famous cultural center of Bali, a procession winds its way through the paddy fields. These dancers form a *gambuh* troupe; they perform one of the oldest dance-dramas on the island. It depicts chivalrous heroes and historical episodes from Bali's mythical past.

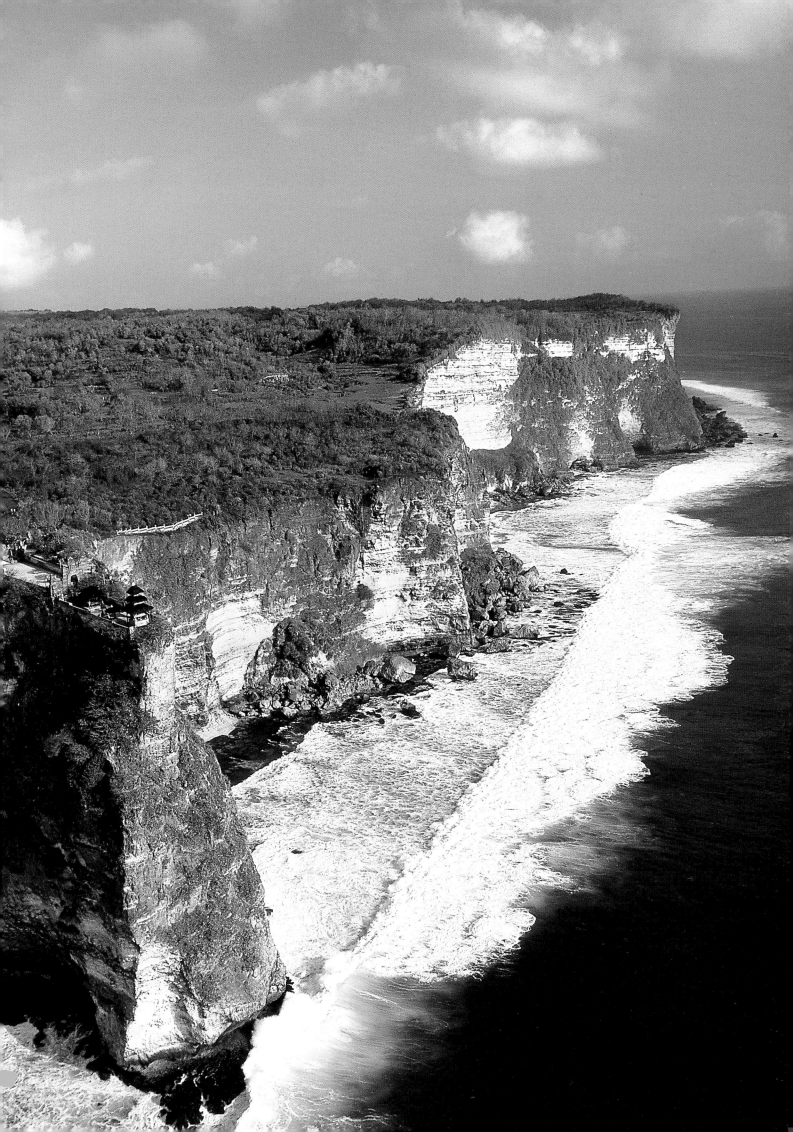

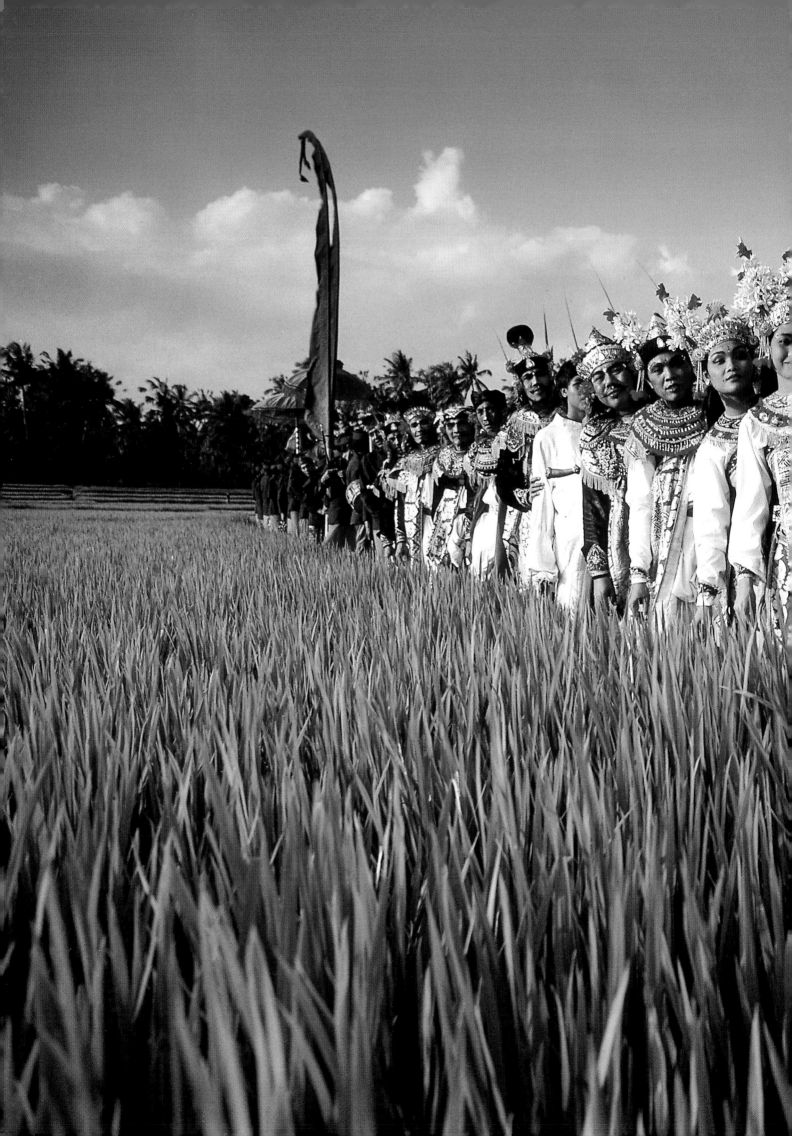

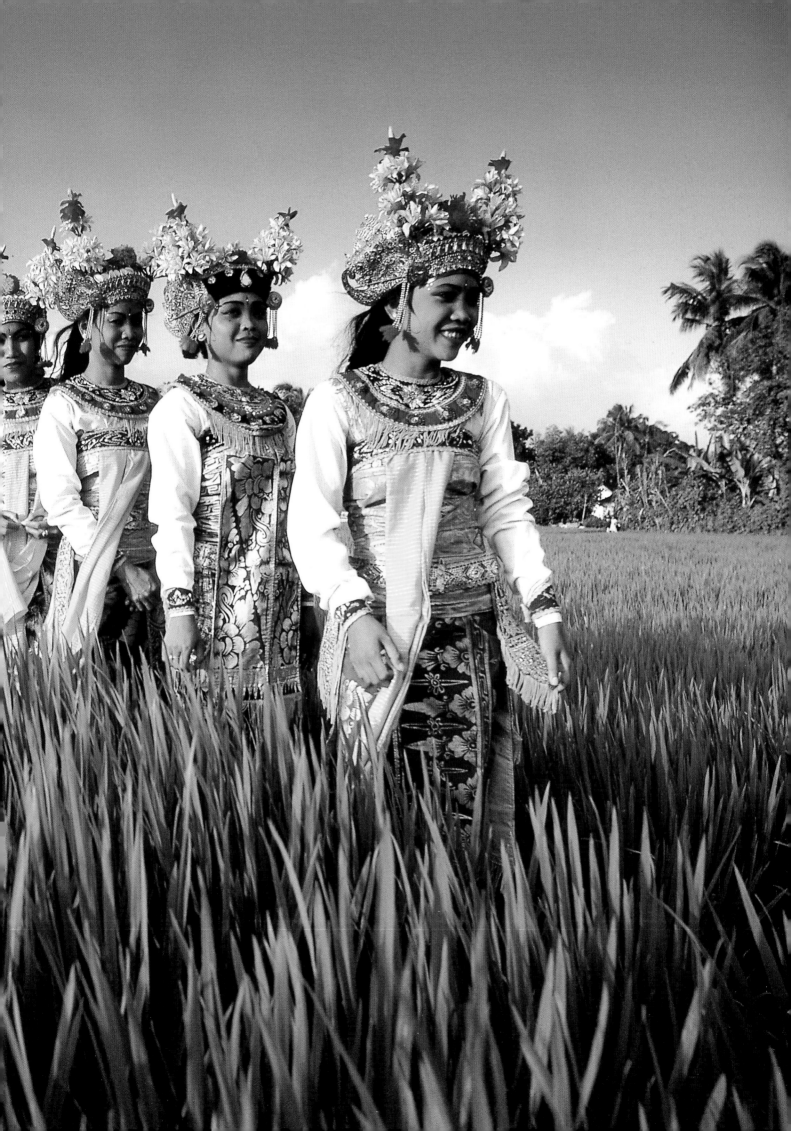

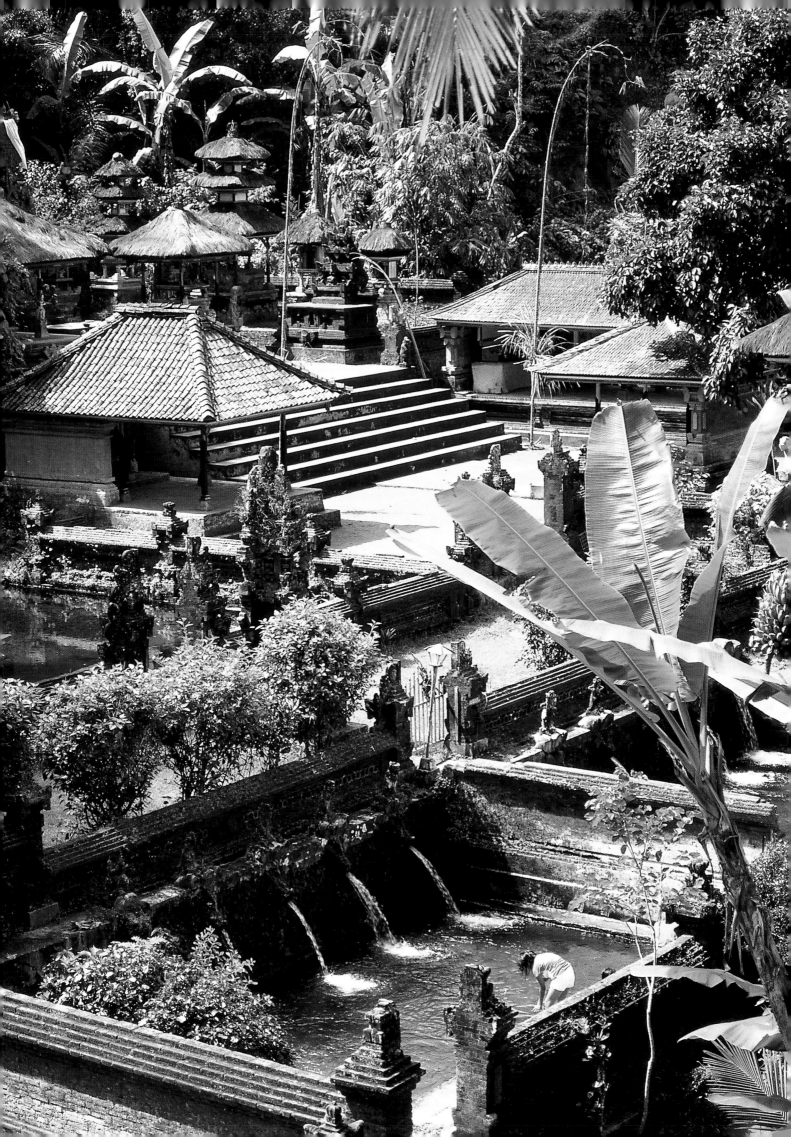

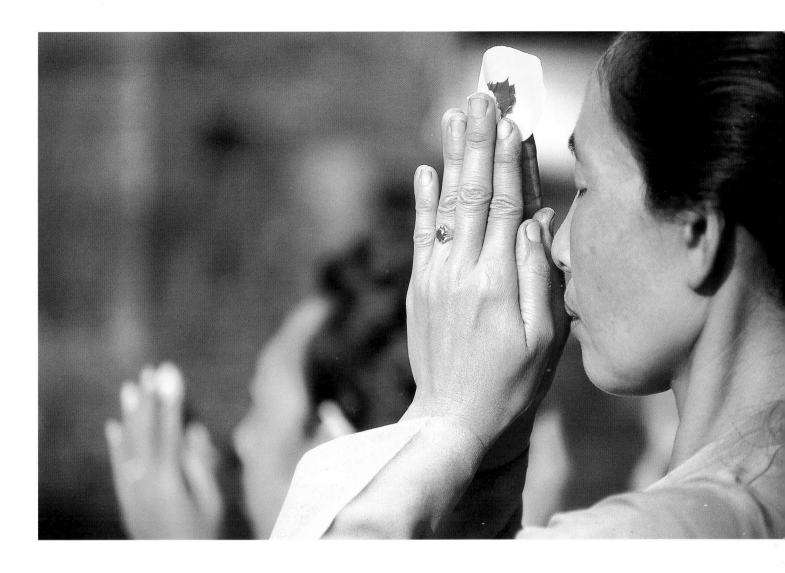

Left: Water from the mountain springs courses through a holy temple complex of courtyards and pavilions. Channeled water and pools have always been considered sacred sites, since water is so vital to Bali's rice agriculture.

Above: In a moment of single-minded prayer, a woman presents a flower offering. As a gift to the gods, offerings must be pleasing but they can be as simple as a petal or a few grains of rice on a banana leaf. Each day of the week has special spiritual attributes that determine what type, color and form each offering should take.

Right: Religious festivals constitute a major part of Balinese culture. Every Balinese can expect to participate in a dozen or more village and regional festivals every year, each one lasting several days.

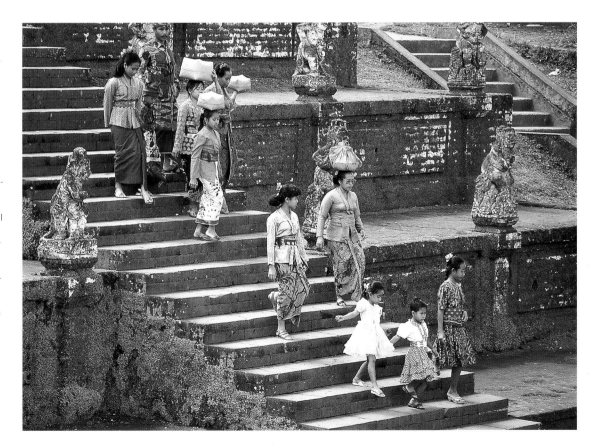

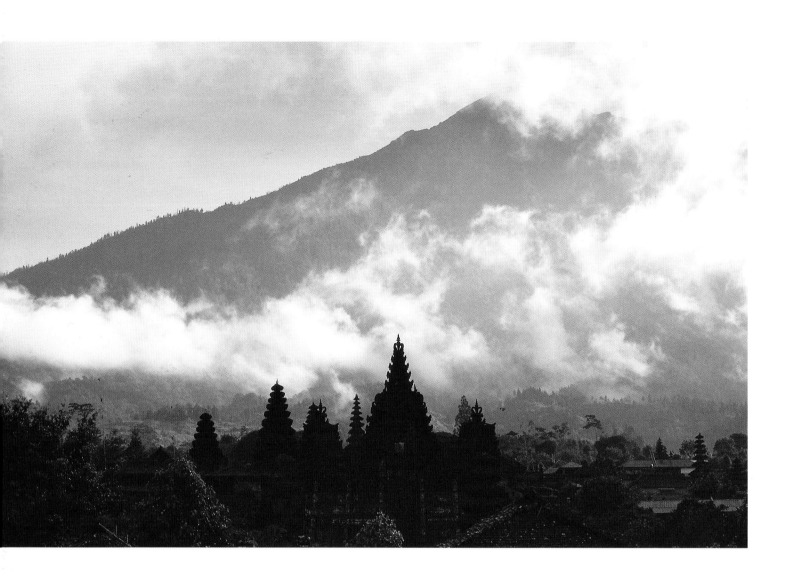

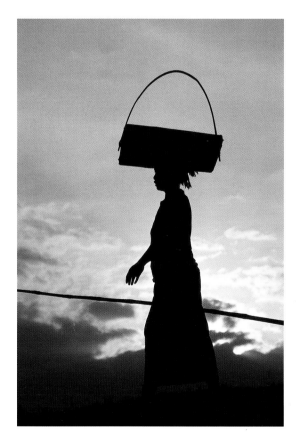

Above: Besakih Temple lies under the shadow of Mount Agung at an altitude of 3,000 feet (950 meters). It represents the most sacred point of the compass for the Balinese and has been a royal ancestral sanctuary since the earliest times. Even the names of the gods enshrined here exist only in Old Balinese, predating influences from India or Java.

Left: A Balinese woman returns to her village at dusk.

Opposite: Women wash clothes in the morning light of Lake Bratan, one of three lakes lying within a huge volcanic basin. Bali boasts four great volcanoes that stretch in a jumble from west to east, culminating in Mount Agung, the island's tallest and holiest.

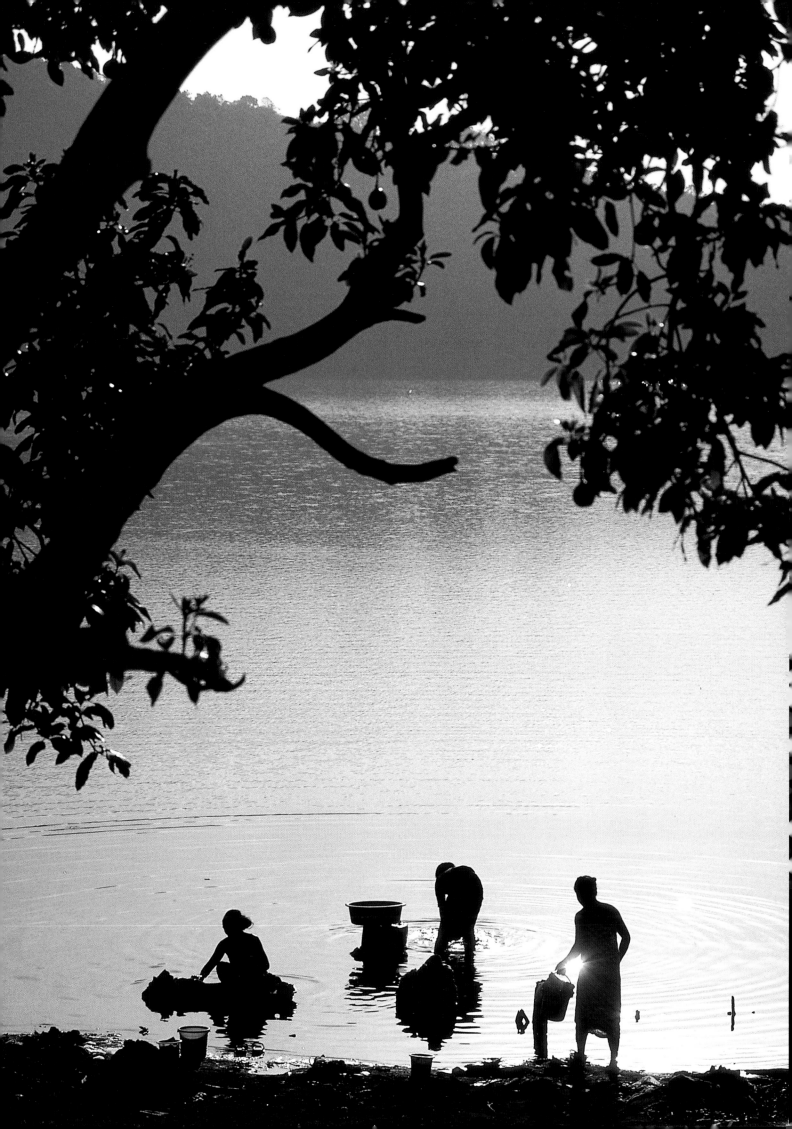

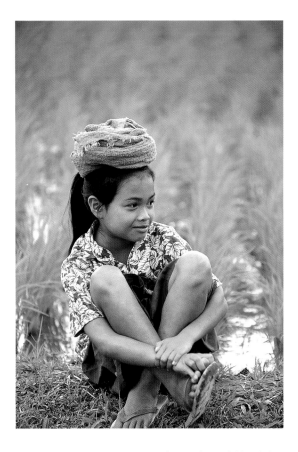

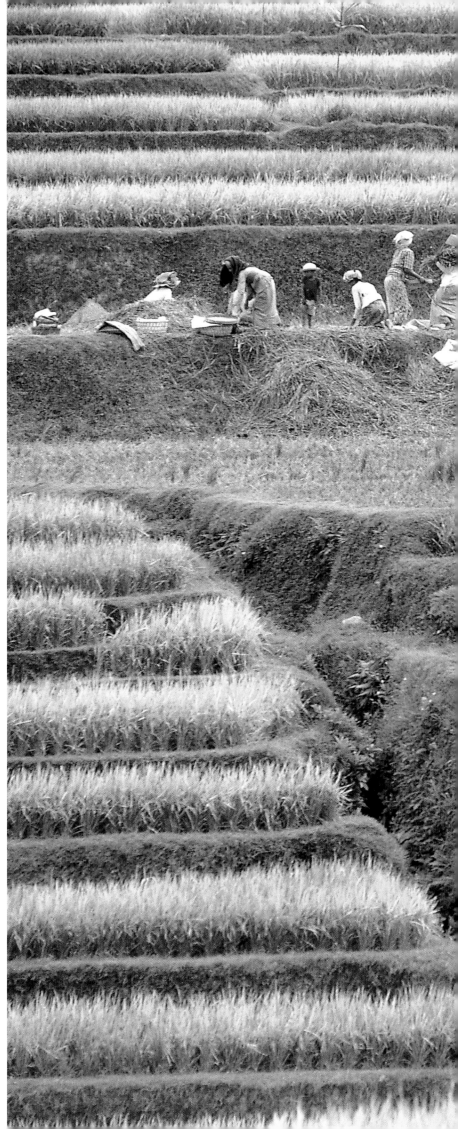

Above: Balinese children help their parents in the fields, as in all other activities, from a very early age.

Right: Harvesting rice is hard work, but the labor is done communally with a sense of anticipation of the rice cycle. In Bali three words for rice are used: *padi*, origin of the English term "paddy", indicates rice that is still in the field; *beras* means threshed rice; and *nasi* is the final form of the cooked, edible grain.

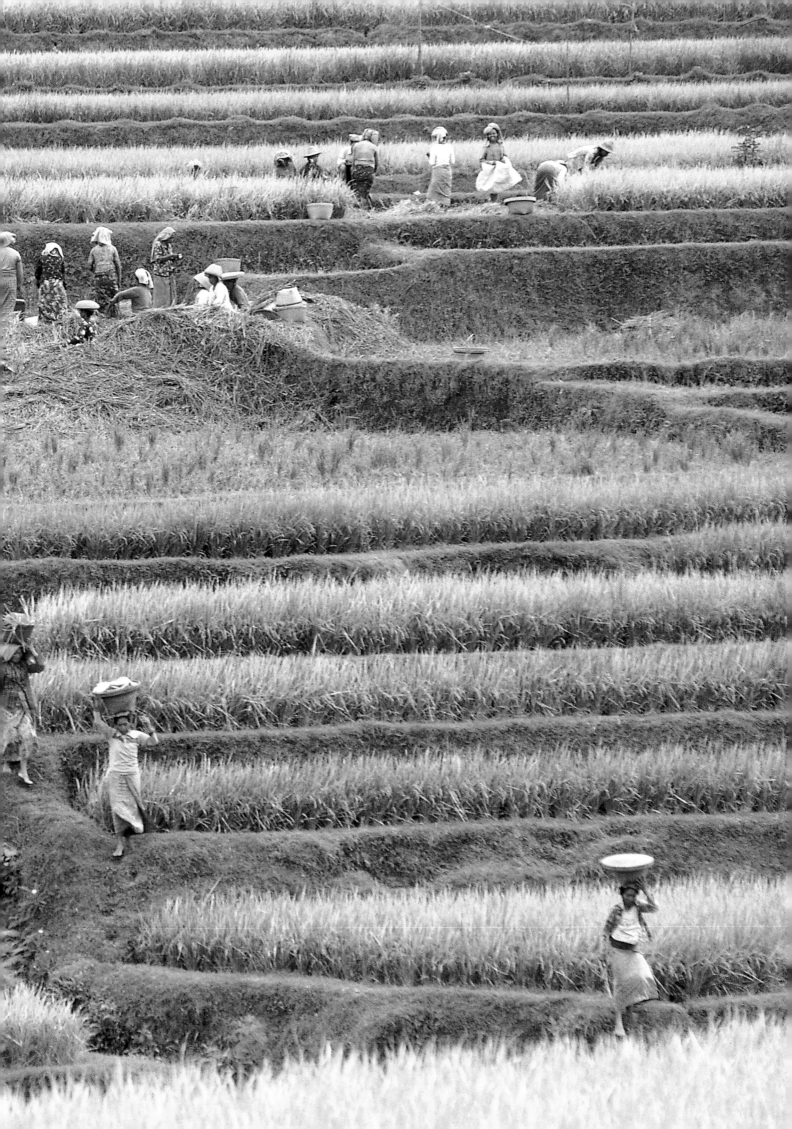

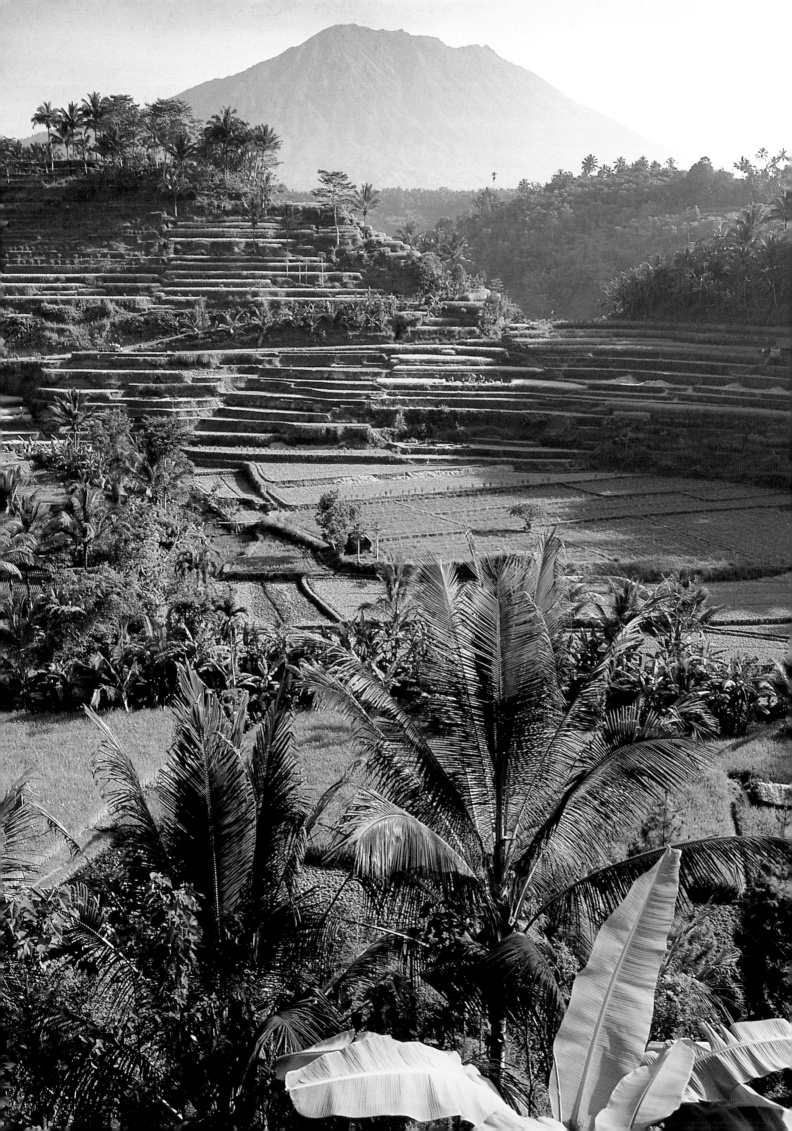

Opposite: Emerald fields of rice run through hills and valleys to the abrupt slopes of Mount Batukau, a volcano that rises to 7,467 feet (2,276 meters). All rice fields in Bali that use irrigation are organized into irrigation cooperatives called *subak* and each of these groups has its own temple and village organization to look after it.

Left: Temple sculptures (top) and bas reliefs (middle and bottom) are common architectural features on Bali. The bas reliefs are carved out of *paras*, a relatively soft volcanic stone.

Below: An 11-tiered *meru* tower rises above the forest. These pagoda-like structures, a common feature of temple architecture in Bali, must have an odd number of storeys to fulfill their magical function of protection. *Merus* are symbolically associated with Mount Agung, Mountain of the Gods. The little roofs are made of sugar-palm fiber and are sometimes now covered with corrugated iron.

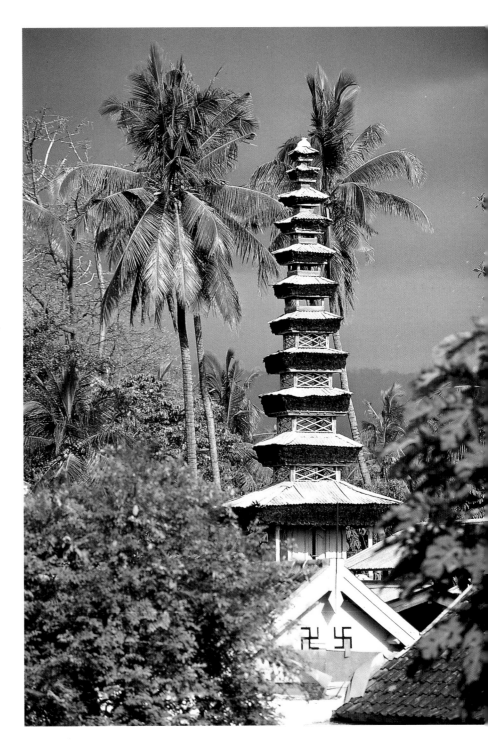

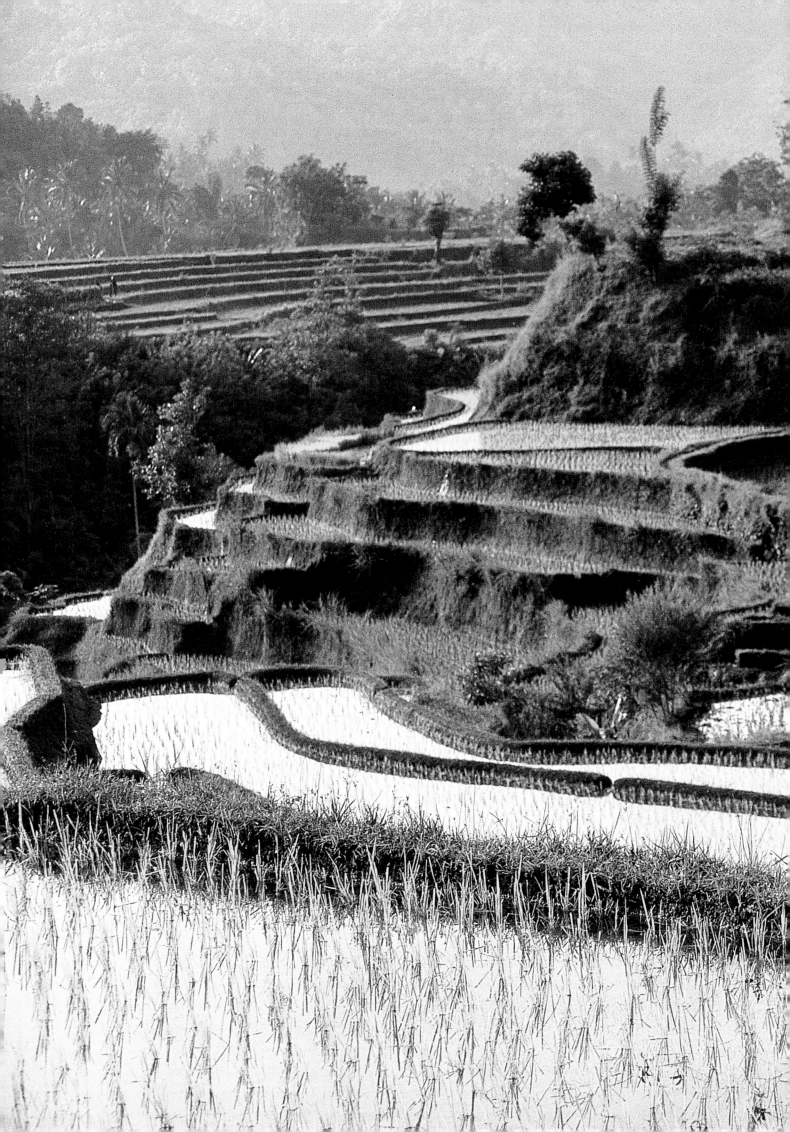

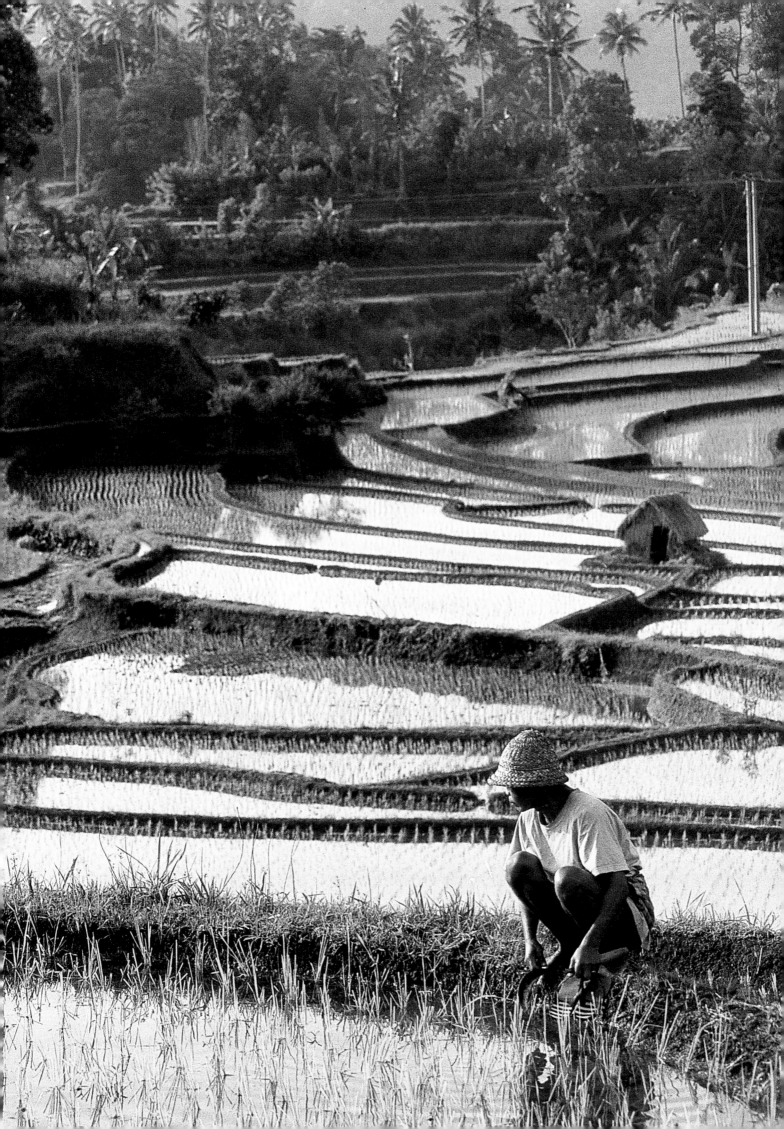

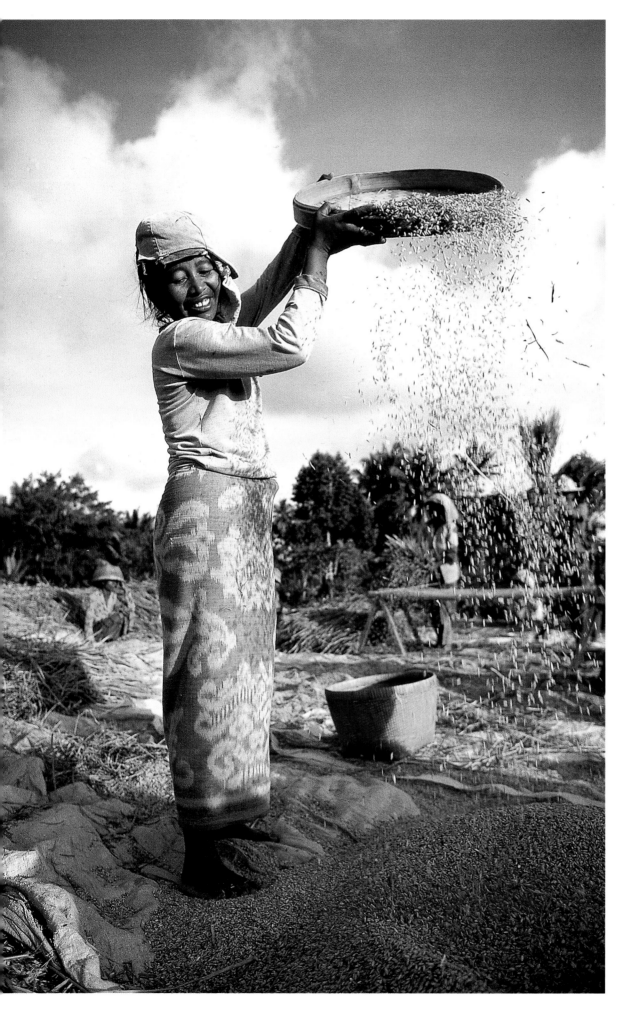

Pages 34–35: Wet-rice cultivation in Bali is controlled by irrigation cooperatives known as *subak*. Each *subak* organizes ritual offerings and festivals, and the planting and harvesting times are coordinated based on the planned diversion of irrigation water through an elaborate system of dikes, viaducts, sluices and channels.

Left: A woman uses the evening breeze to help winnow the rice chaffs from the grains.

Opposite: A temple courtyard is used as a threshing ground. Once individual grains of rice have been separated from the ear they are swept up and bagged; they are then ready for sale or distribution before the final process of husking and polishing.

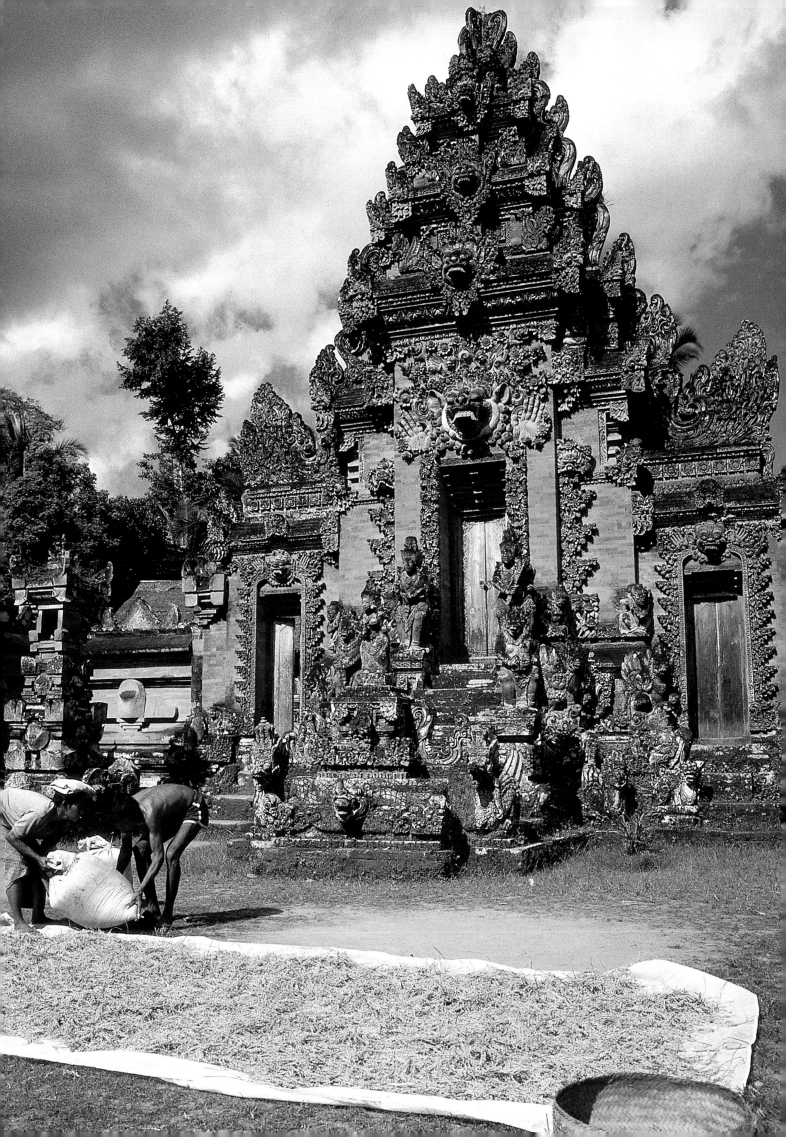

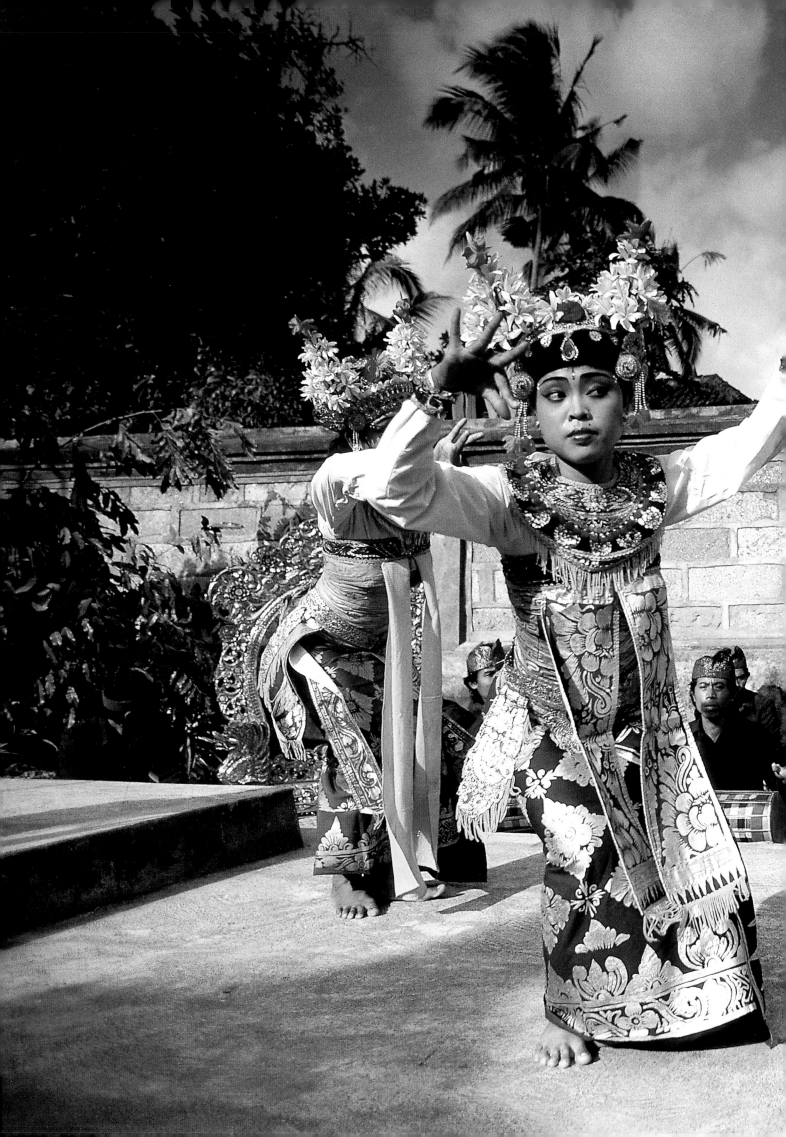

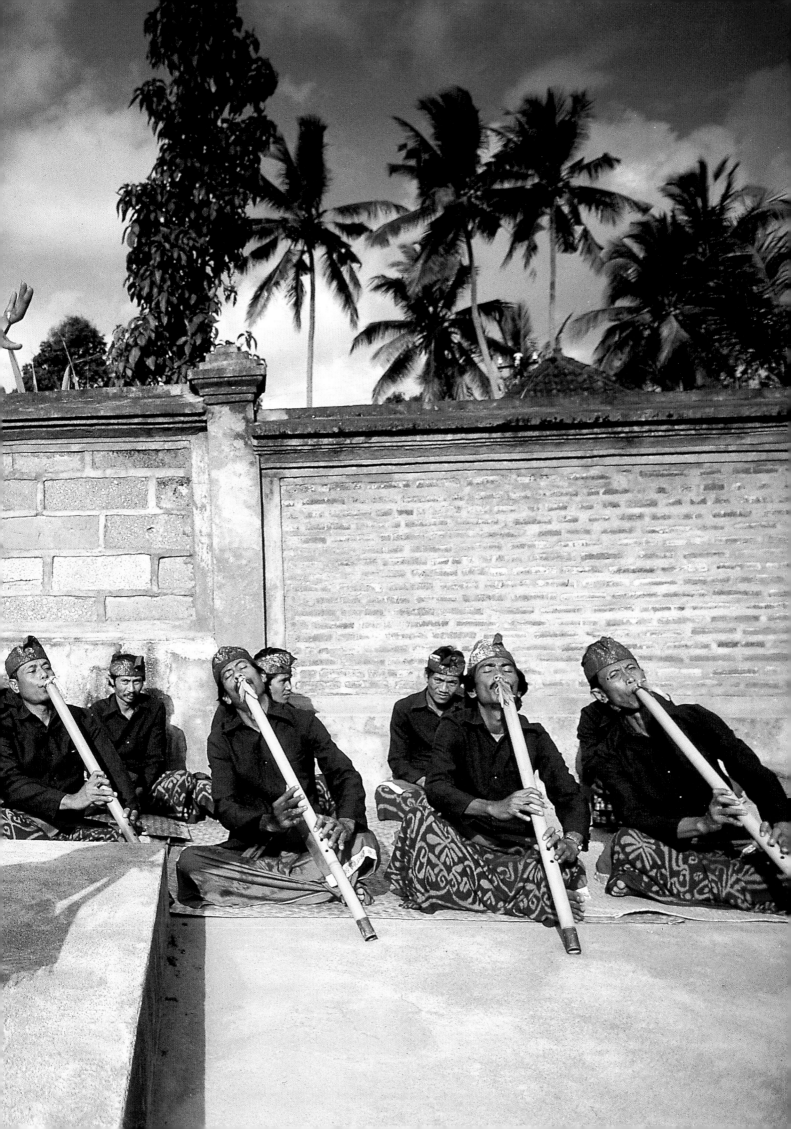

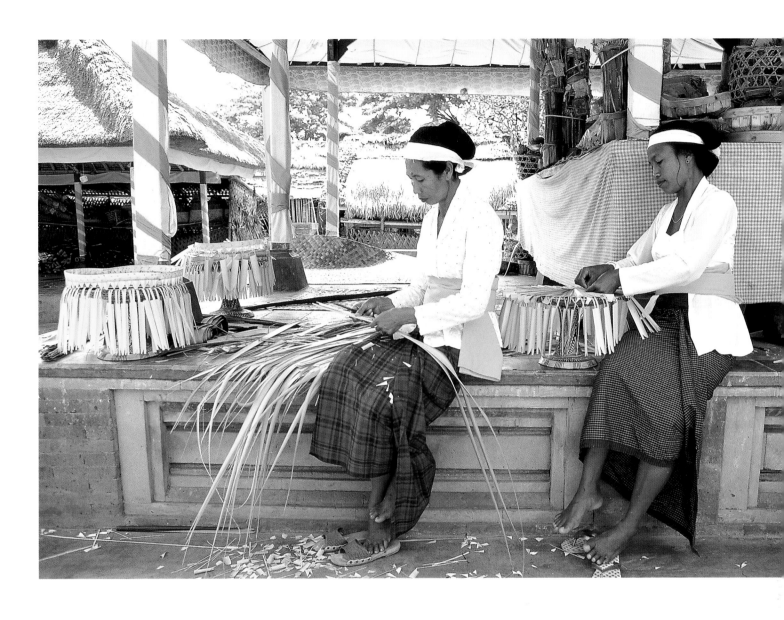

Pages 38–39: The *legong* dance-pantomime is the best loved of classical dances in Bali. Only very young girls perform the *legong*, often beginning their training at age five. By 14 they are considered too old and retire from this style of dancing. The girls are called "divine nymphs" and act the roles of highly refined courtiers.

Above: A group of women make temple offerings. Stripped palm fronds will be folded and pinned to create *lamaks*, pretty, perishable decorations (right) that usually last one or two days before becoming wilted and spent.

Left and far right: Sometimes detailed, other times stylized and made of simple palm leaves, the *cili* is representative of a beautiful goddess with a slender body and large headdress. She is the goddess of Life and Fertility, associated with the rice plant.

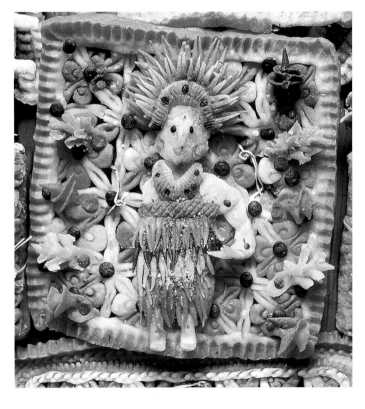

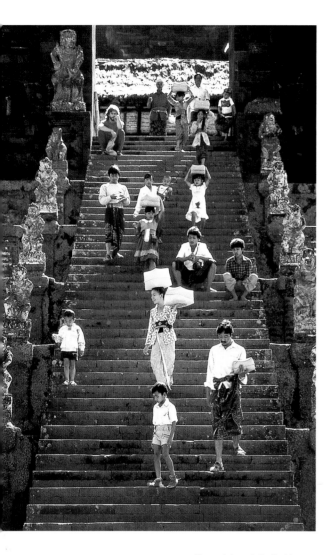

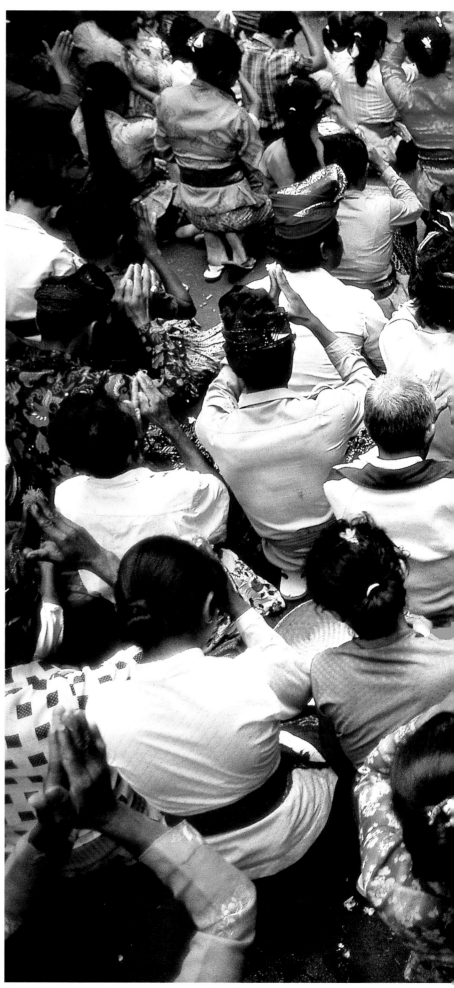

Above: A temple festival in Bangli. This temple, Pura Kehen, has a history of 800 years and is a fine example of the southern style of architecture. It is built of reddish-pink brick and has intricate carvings in grey and pink sandstone.

Right: A colorful crowd, united in their devotion, celebrates a temple festival. It is the *odalan*, the birthday of the temple's founding, held every 210 days, and the whole village attends, dressed in their finest clothing. The festivities, lasting for one day and night, mark a fresh beginning for the temple year.

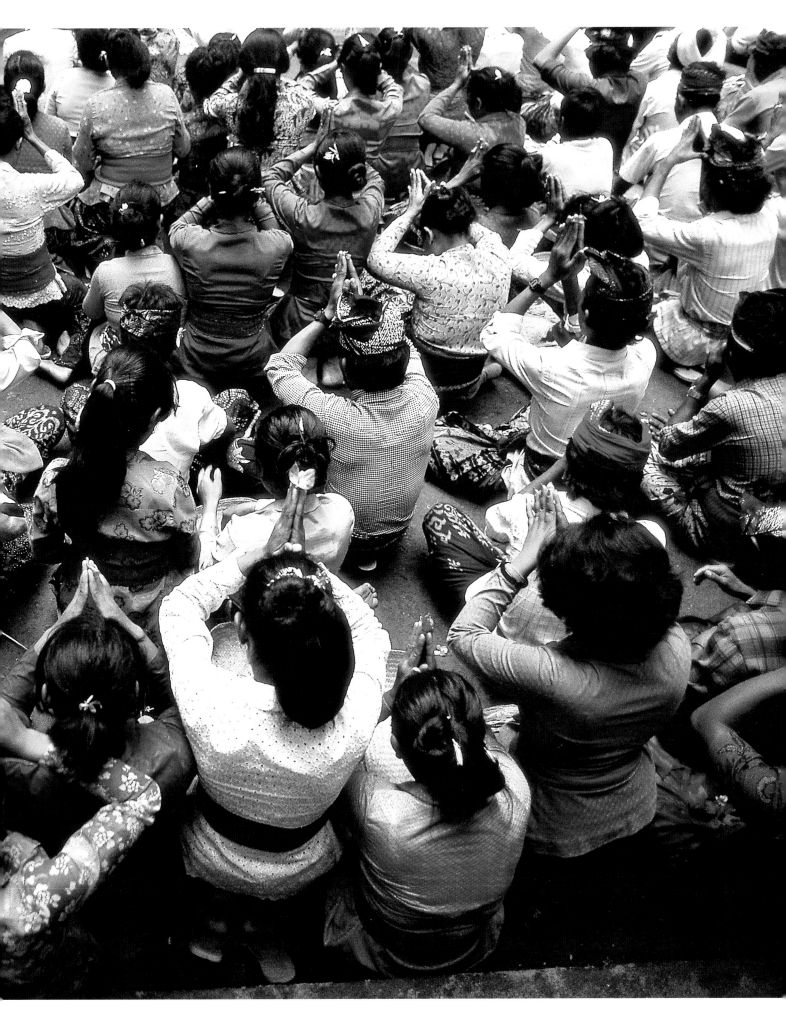

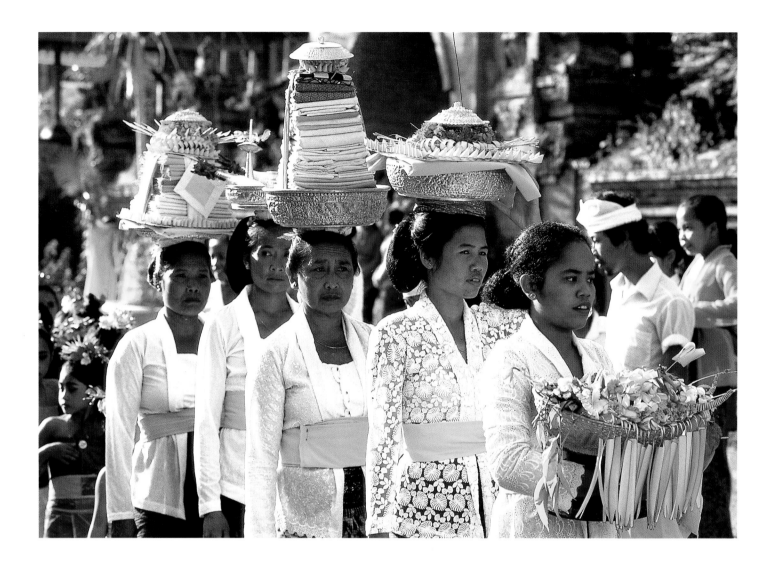

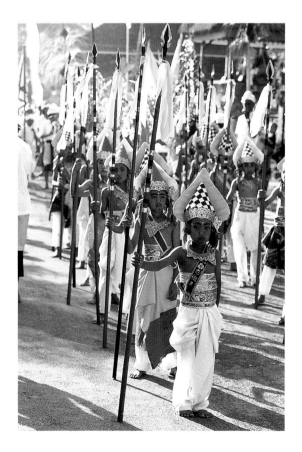

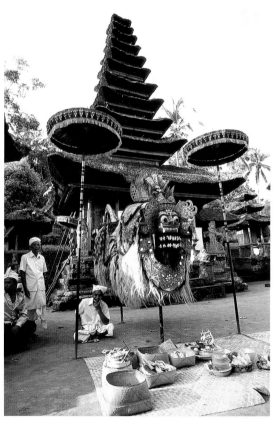

A huge procession forms part of every *odalan* celebration to mark a village temple's anniversary. Days of preparation go into a successful *odalan* and the culmination is a march to the sea where statues of the temple gods will be give a ritual bath. Women (above) with waists wrapped in beautiful saffron scarves carry offerings of food and clothing, flowers, fruit and holy water. Gongs and orchestral music accompany the procession amidst the general noise of the crowd.

Pages 46–47: Young Balinese girls attend a temple ceremony dressed in their finest clothing and bearing delicate offerings fashioned from palm leaves.

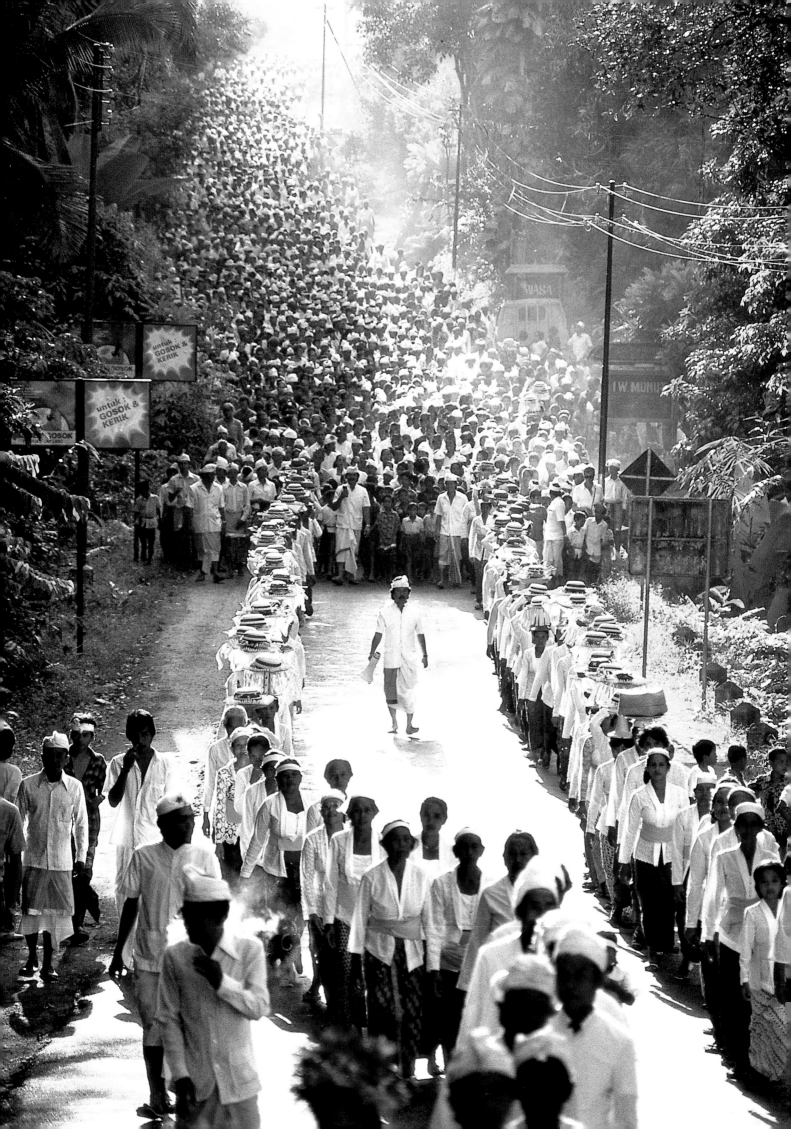

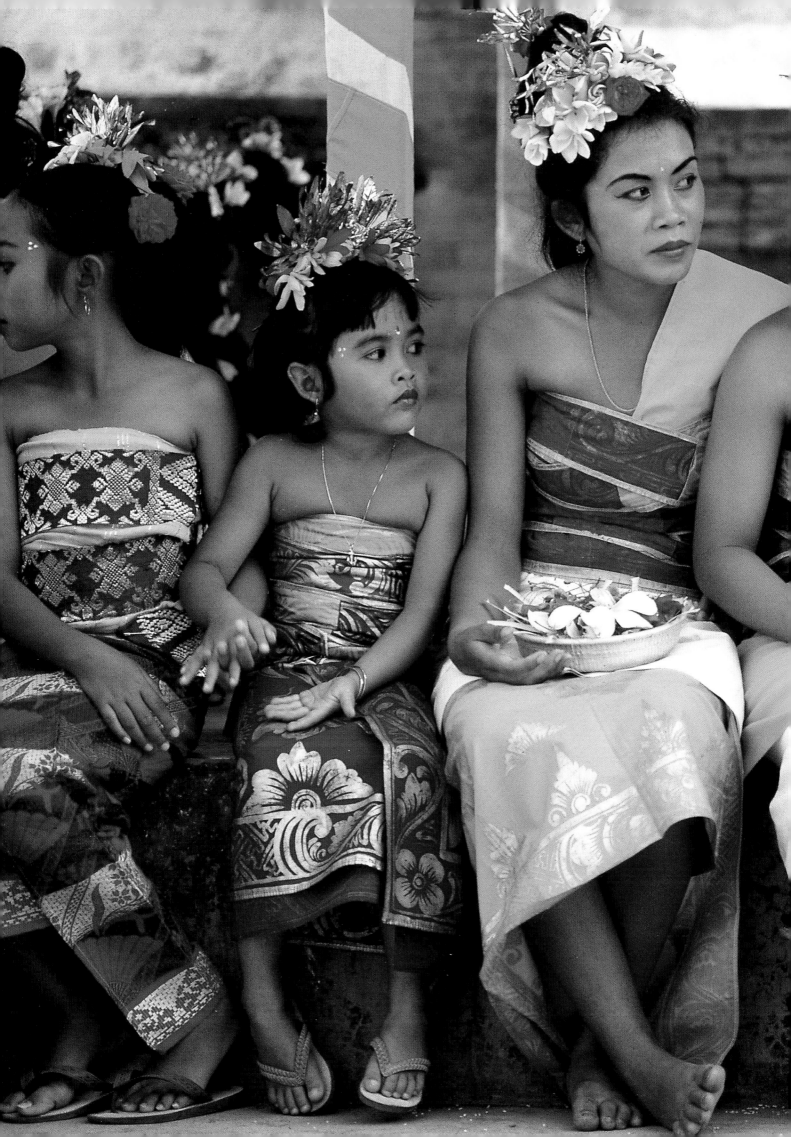

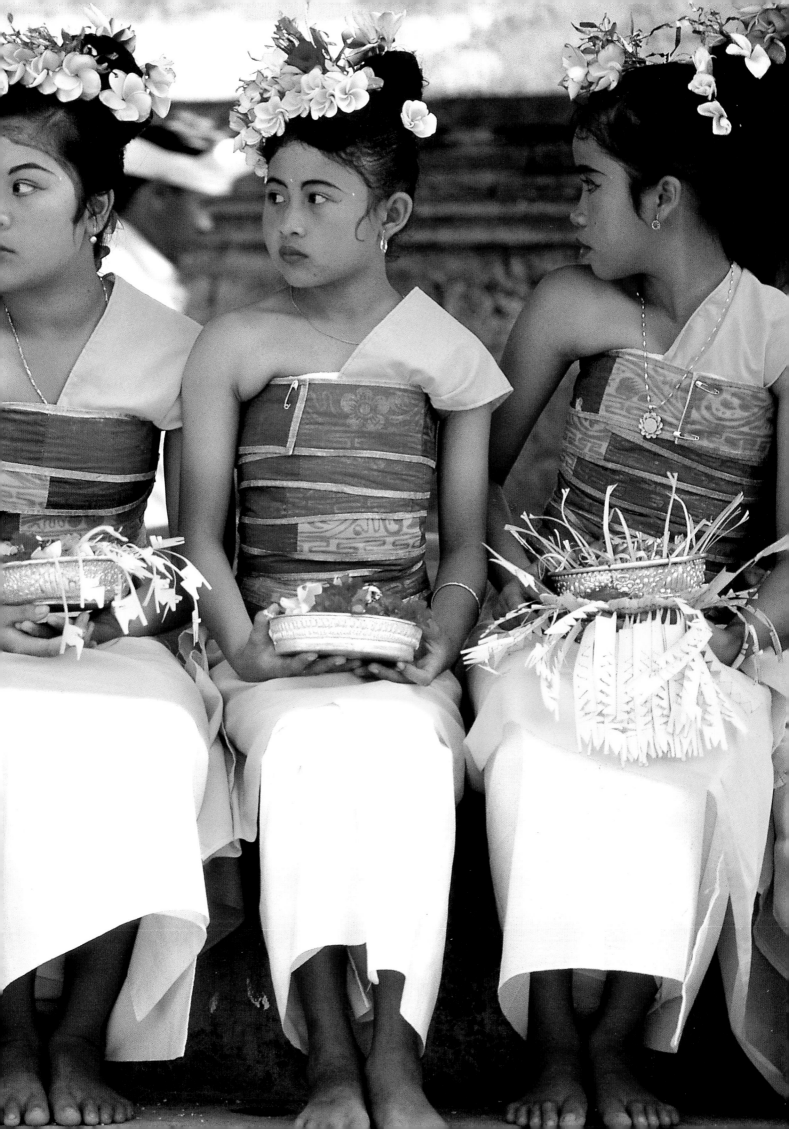

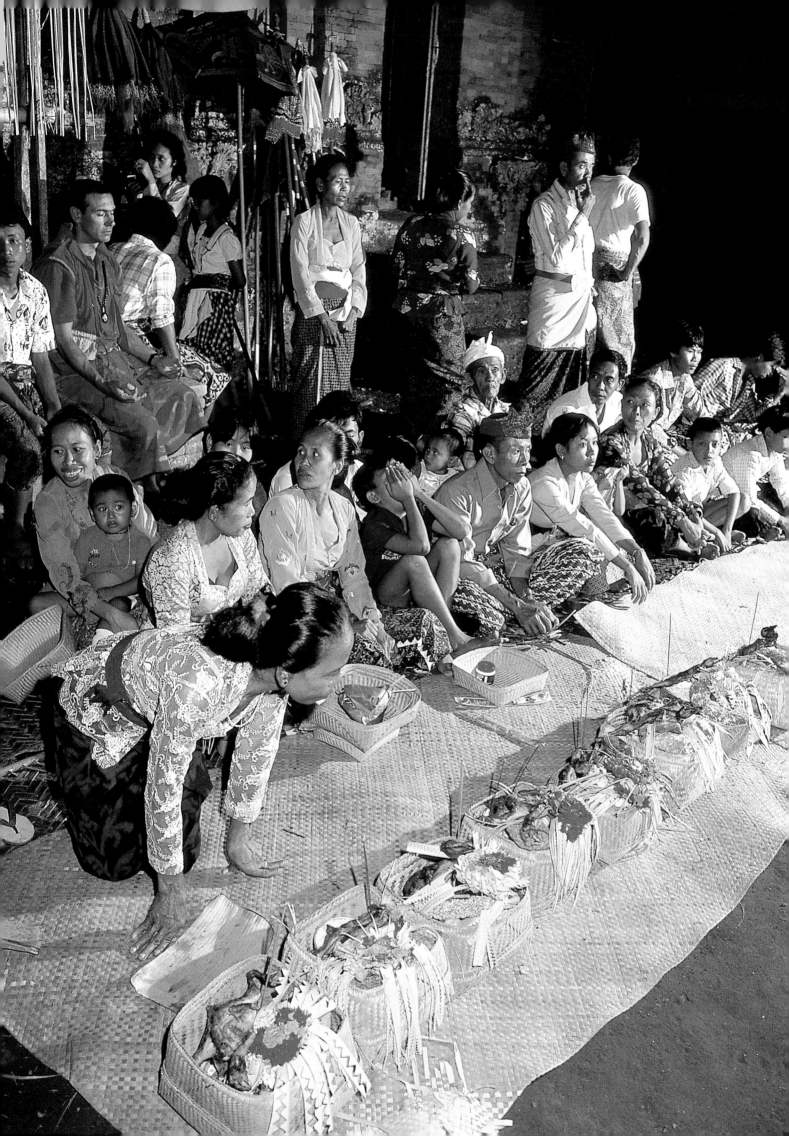

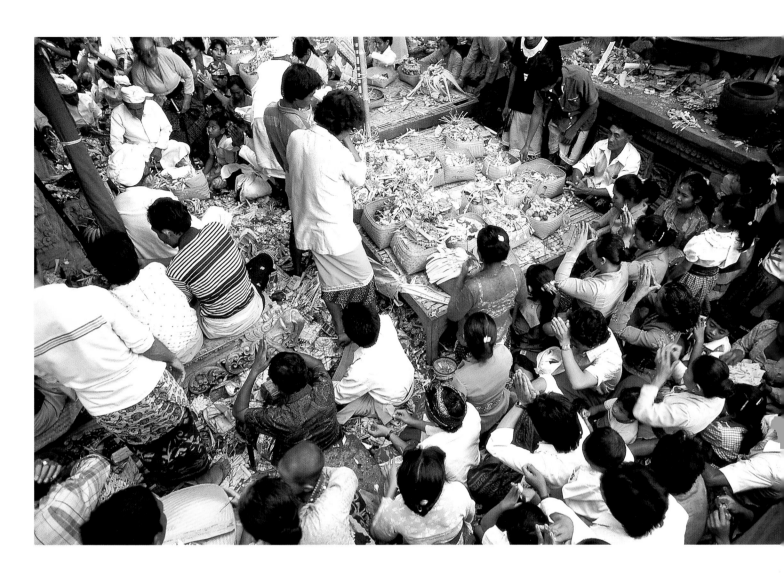

The Balinese present ritual offerings to the spirit world as marks of respect and gratitude. Offerings are also made to appease demon spirits so they do not attempt to disrupt the balance of life. Simple offerings are presented virtually everyday around the household (as well as in shops or offices), while more elaborate ones (right) are reserved for ritual days.

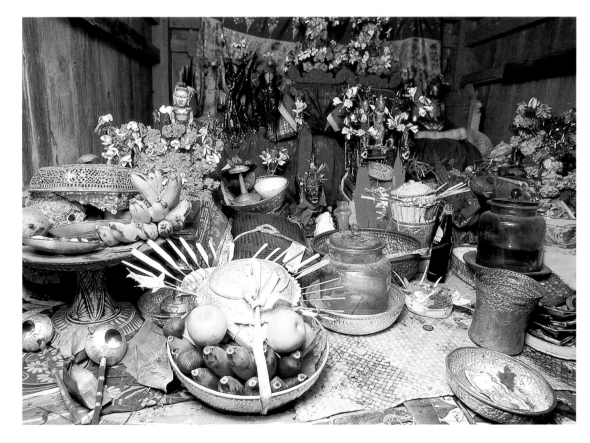

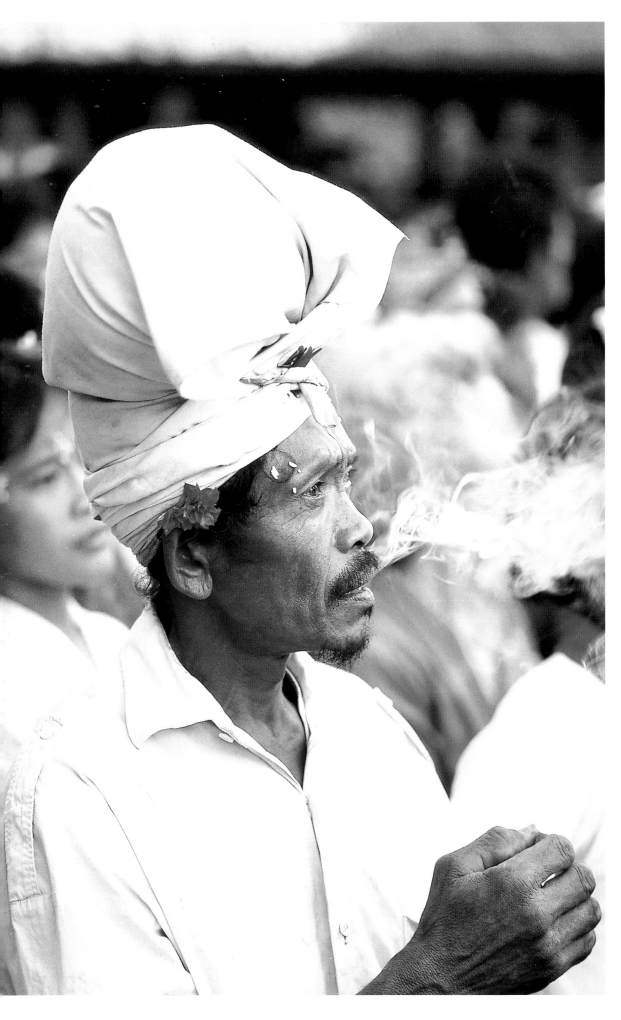

A concerned onlooker (left) watches as a group of young men lose control in a state of trance (opposite). Friends and caretakers of the trance "dancers" keep them from hurting themselves or people in the crowd. Trance is not at all unusual in Bali; it is encouraged as a special state in which people can enter into direct communication with the spirit world and bring back knowledge or special wishes of the deities. Even in moments of ecstasy or self-inflicted violence, trance is rarely allowed to get out of control.

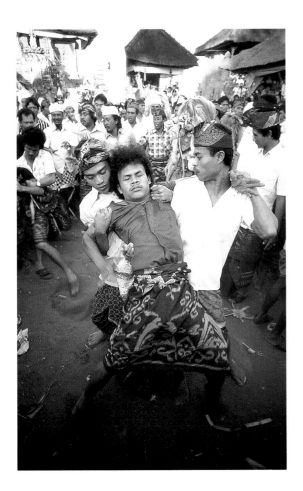

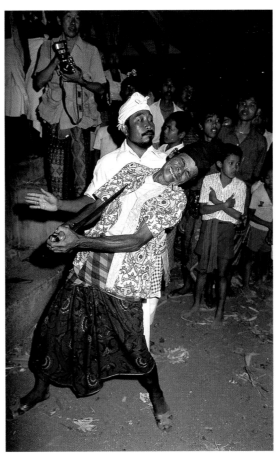

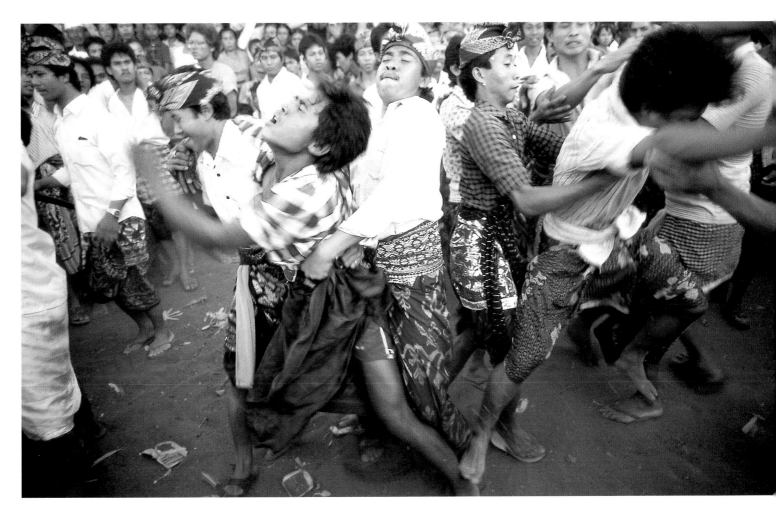

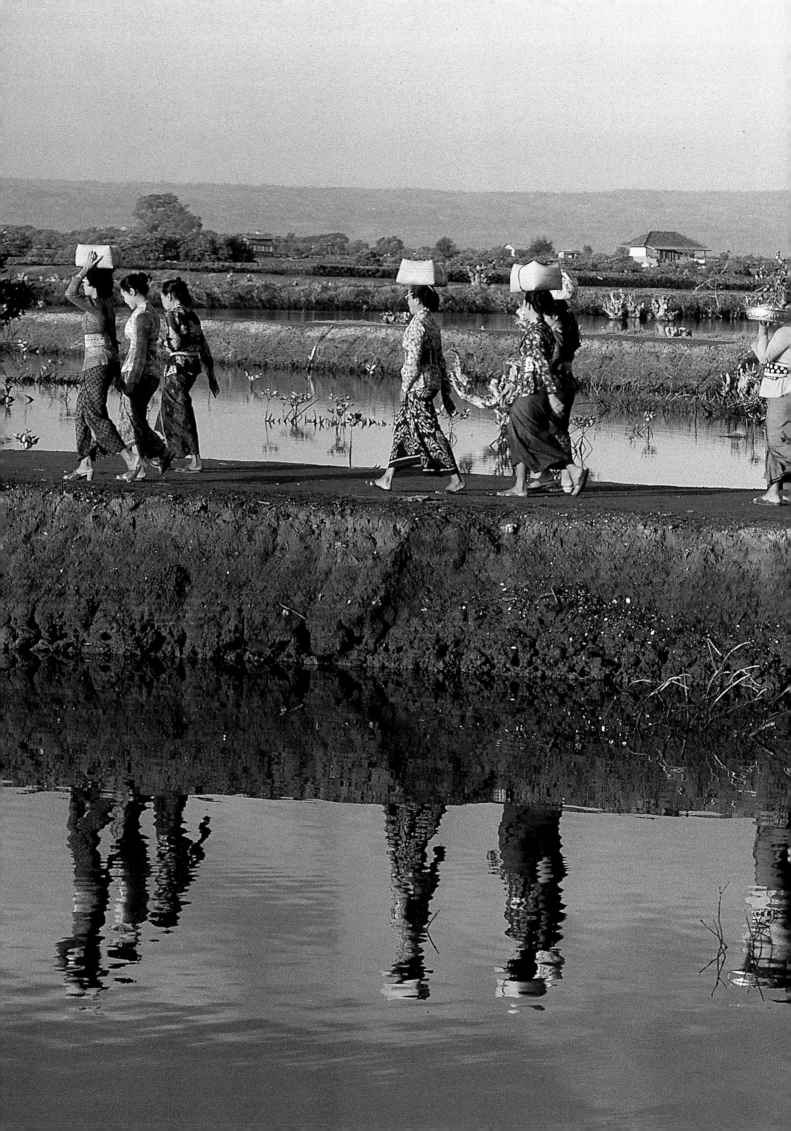

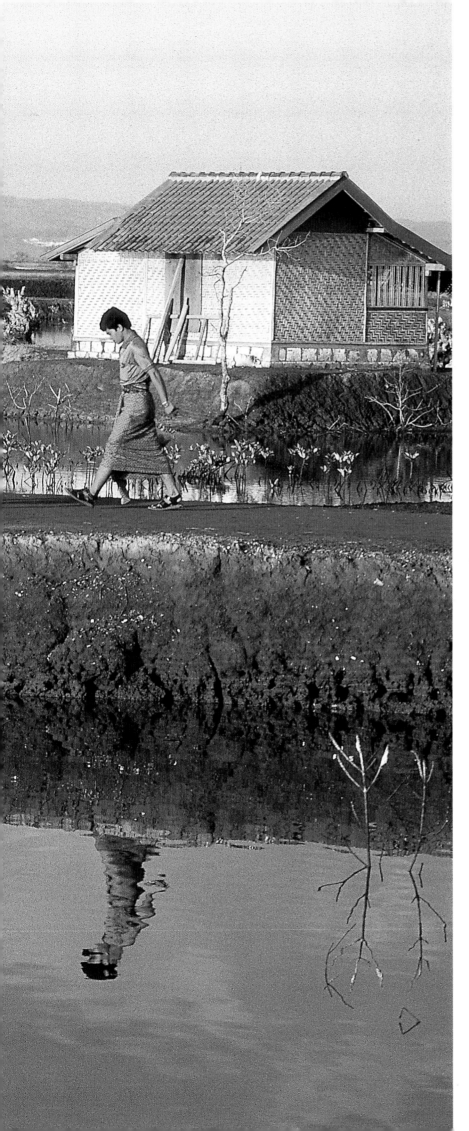

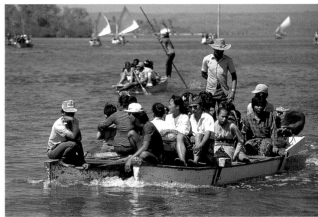

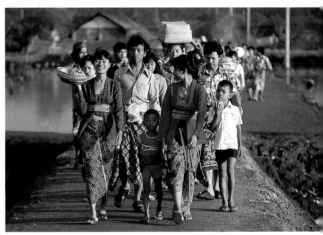

On foot and in overloaded boats, crowds of people head for a festival at the temple of Pura Sakenan, a holy site for the people of southern Bali. It sits on the shores of Serangan Island, better known as Turtle Island for its huge sea turtles. These are especially prized as food for village feasts.

Pages 54–55: Tall banners stand before the temple of Tanah Lot on Bali's western shore. This small, beautifully located temple was founded in the 16th century by Sang Hyang Nirartha, the last important priest to come to Bali from Java. He arrived to strengthen the island's Hindu faith and Tanah Lot, one of the most holy sites on Bali, is a memorial to his efforts.

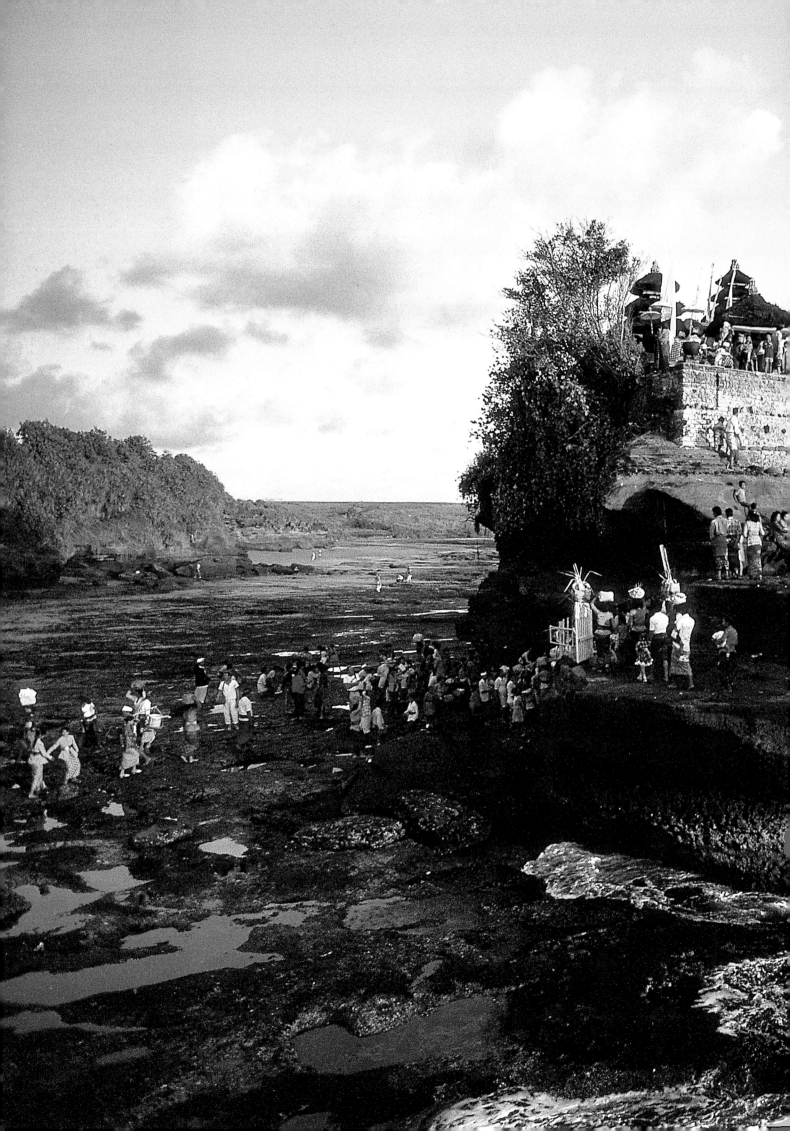

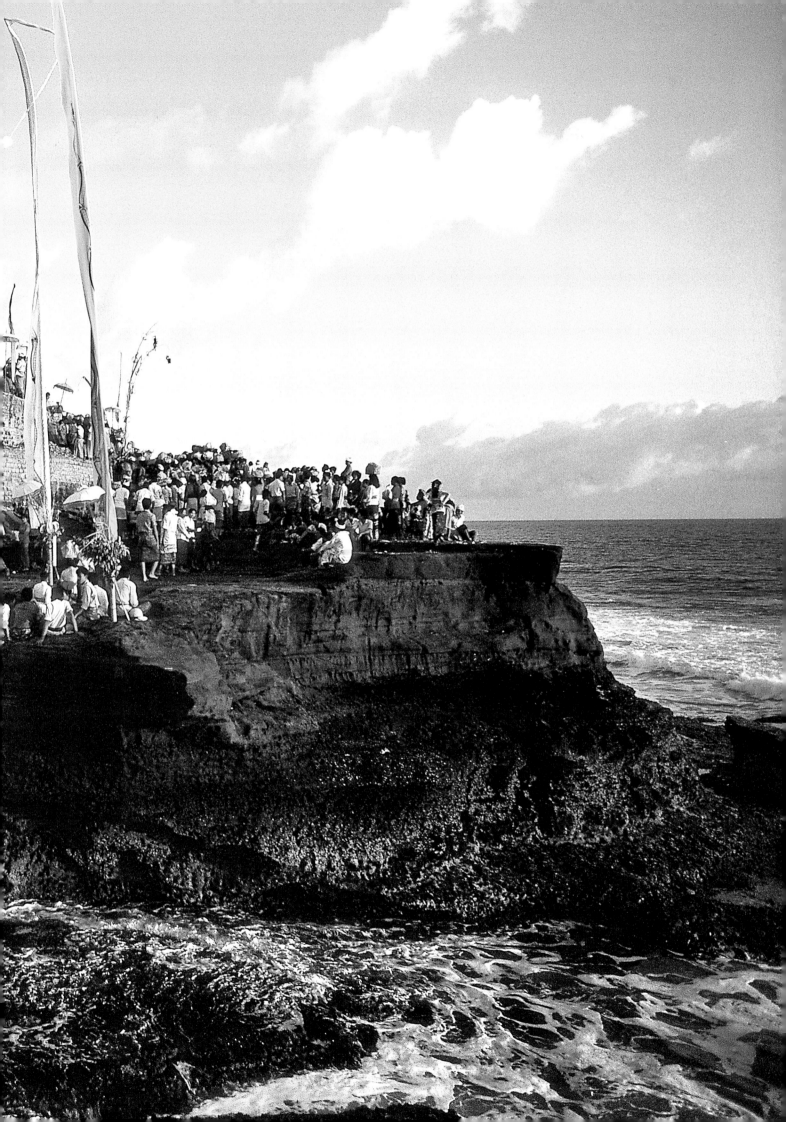

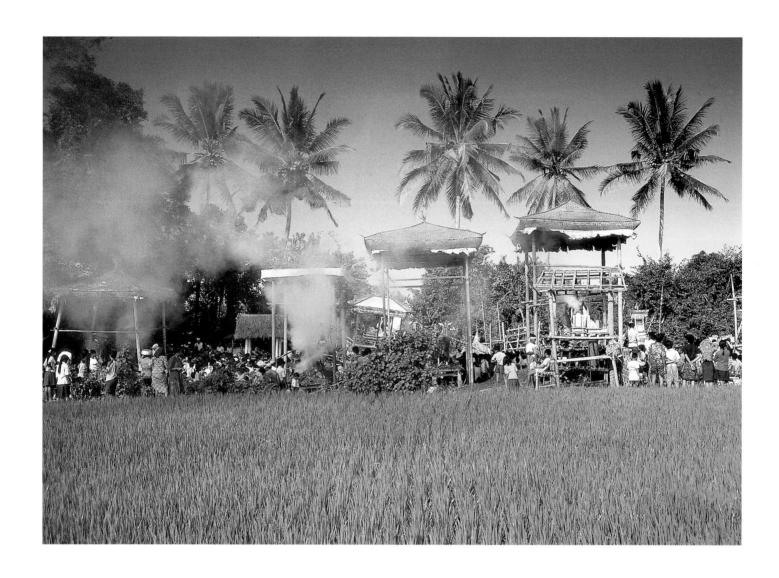

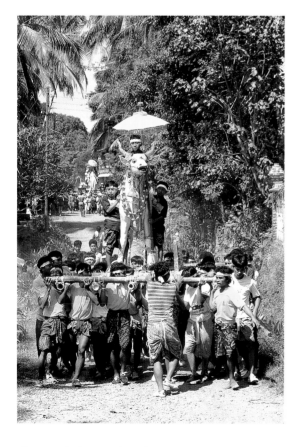

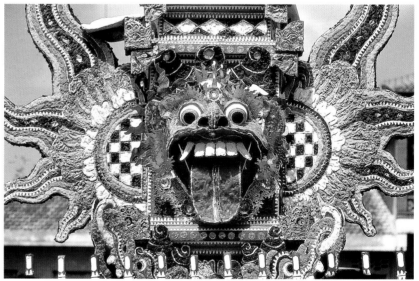

Cremations are a Hindu celebration of passage to another, better life. A cremation is also a social event where families can gain prestige by displaying extravagance in fulfilling a final, sacred duty. Tower-like structures called *badé* hold the body while it is taken to the cremation site. The *Badé* represent the cosmos—underworld, earth, heaven—while the multiple roofs are replicas of the levels of heaven. Bulls and levine creatures are the most common form of sarcophogi.

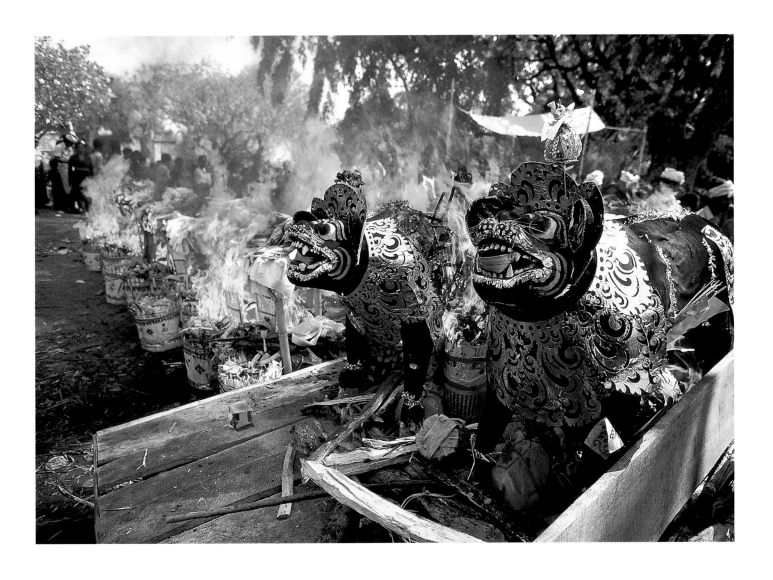

A Brahmanic priest (right) is employed to perform the cremation rituals and he plans and supervises the proceedings—from choosing a propitious day for the funeral (above) to conducting the many rites for the dead.

Pages 58–59: Balinese masks are carved realistically, full of human feeling and expressiveness. A good set of masks is a treasure for the community lucky enough to own it. The most famous mask-dance is the *topeng*, which literally means "something pressed against the face."

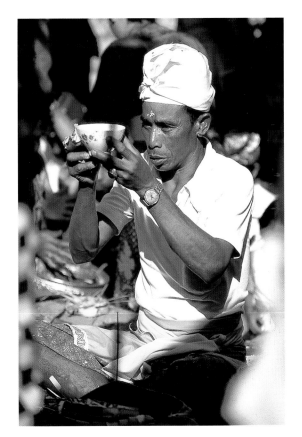

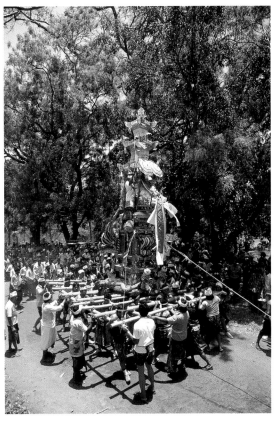

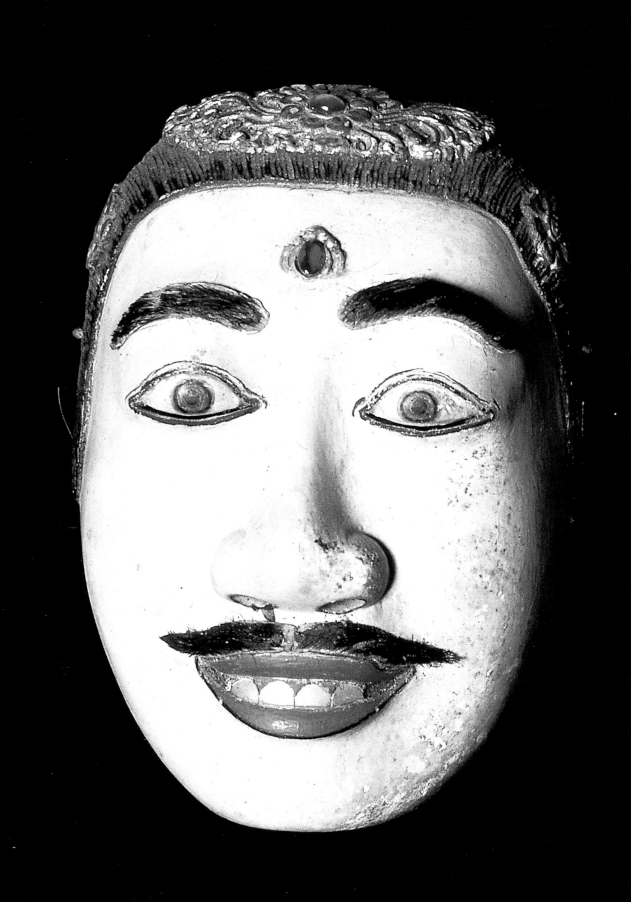

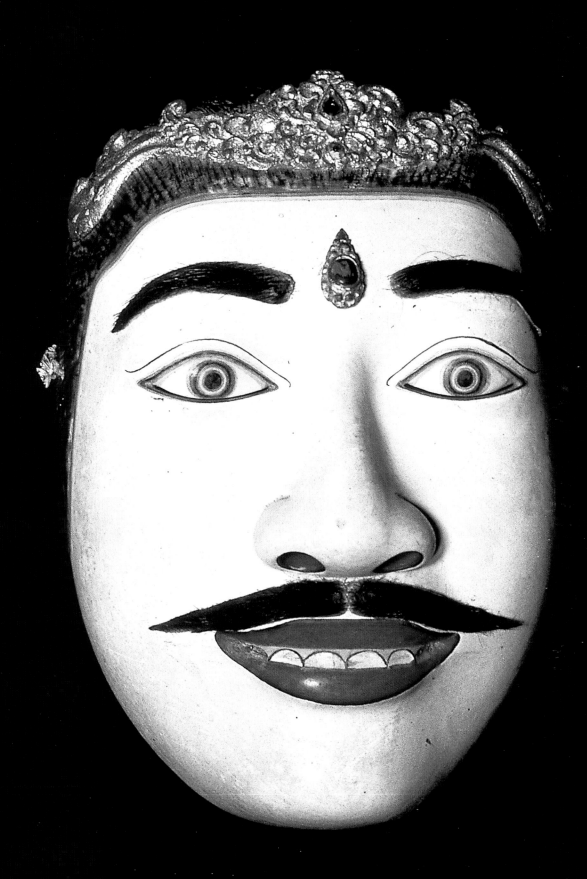

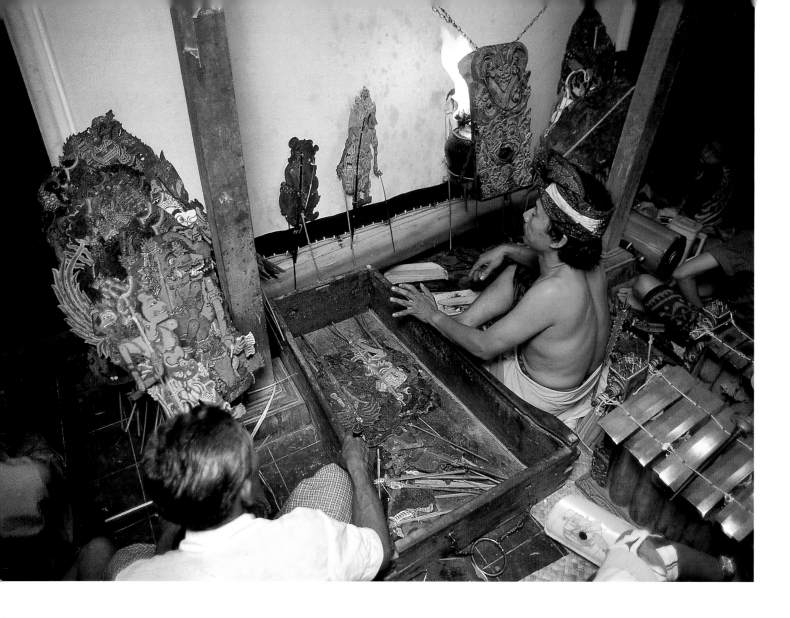

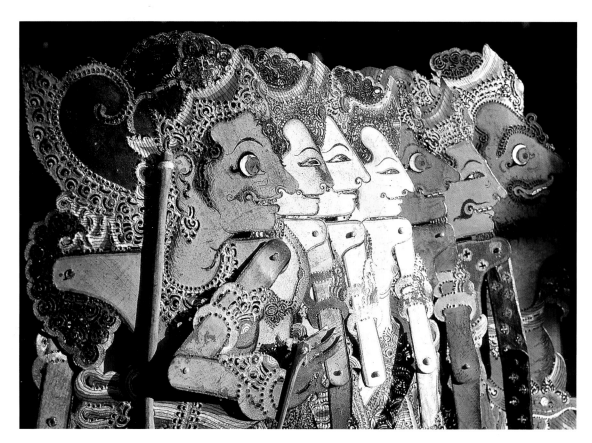

Shadow puppets, seen in profile and projected onto a screen by the light of an oil lamp, are made of thinly cut buffalo skin, painted and gilded to wonderful effect. Known as *wayang kulit*, stage performances of these shadow puppets are the main medium for the transmission of communal values and a sense of shared, epic history, all important in the spiritual education of the Balinese.

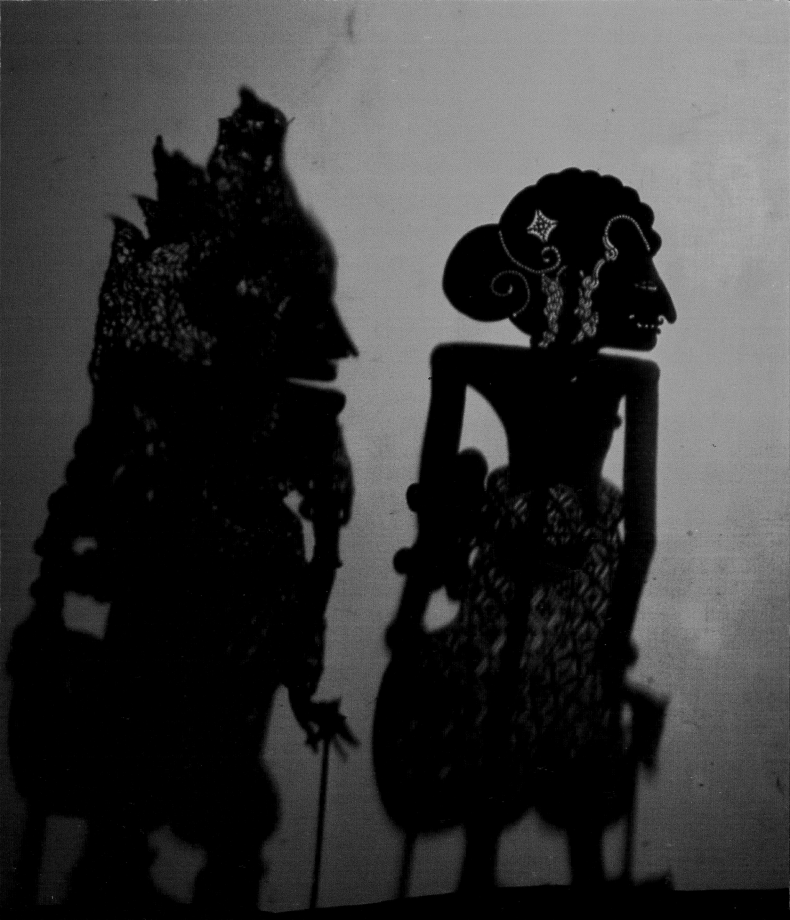

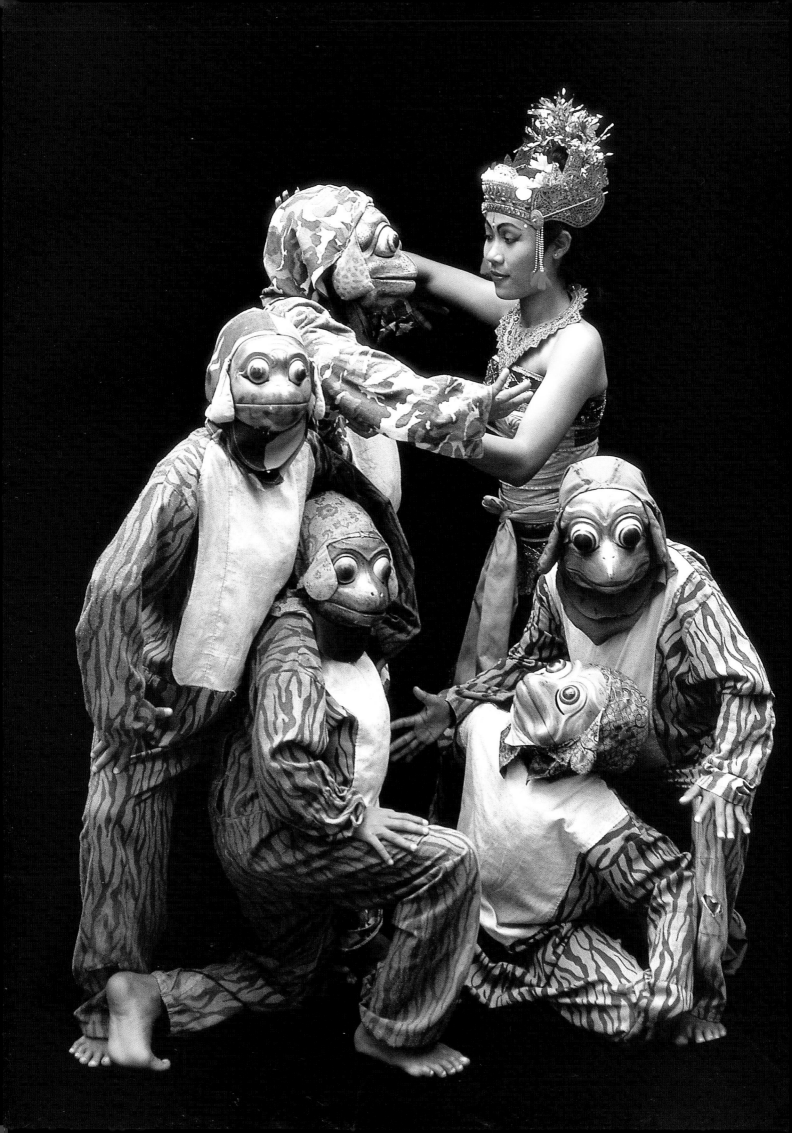

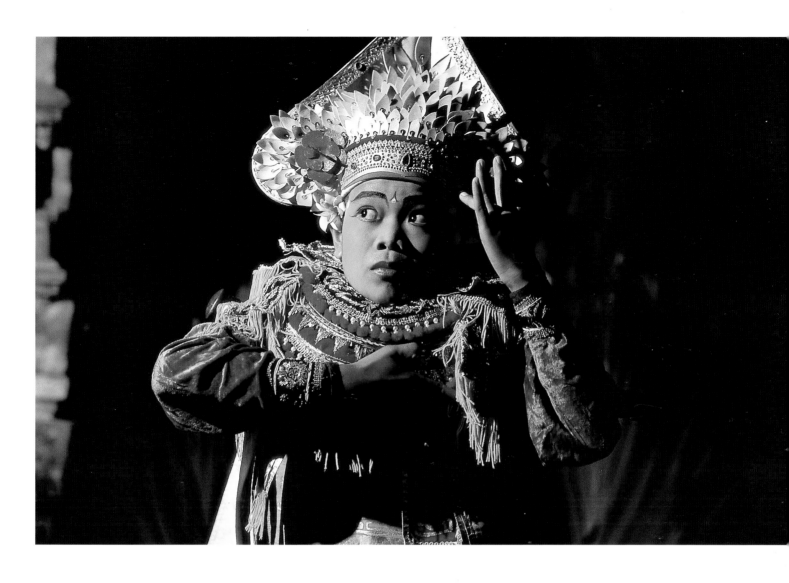

Above: A young *baris* dancer strikes a martial pose. Performers must be fit as all parts of the body, from the forehead to the toes, are used. Music always accompanies the *baris*, and the relation of dance to music is close, with many changes of mood and expression.

Left: This Balinese "princess" and supporting cast of dancers dressed as frog retainers are members of a famous *geng-gong* music and dance troupe.

Right: *Janger* performers in their resplendent costumes. The woman's *petitis*, or head-dress, is a modified form of Balinese wedding crown.

Far right: A dancer dressed as Rangda stands menacingly over a dancer. The Rangda dancer must undergo a cleansing ceremony before a performance as audience members may try to cast magical spells on him.

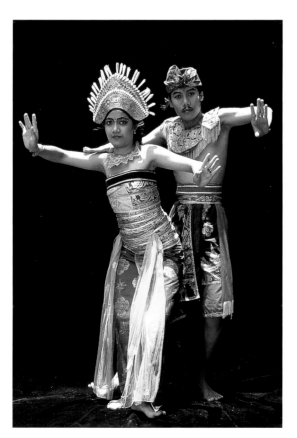

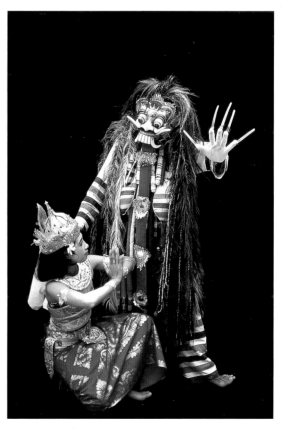

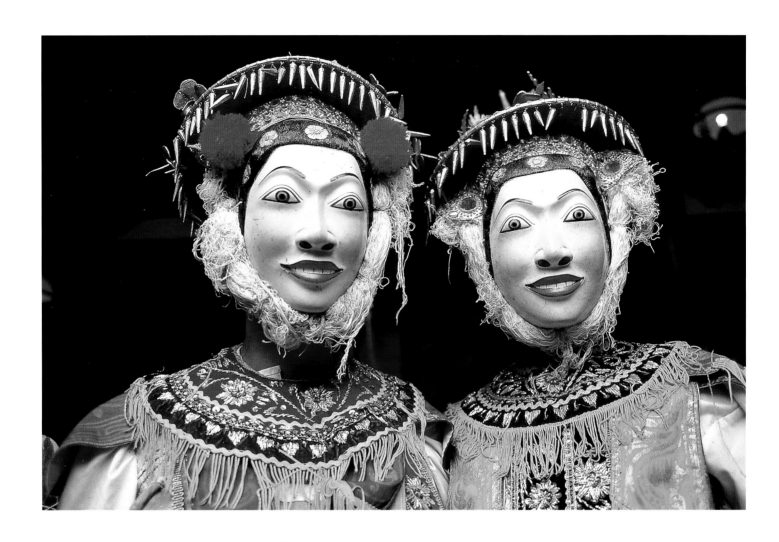

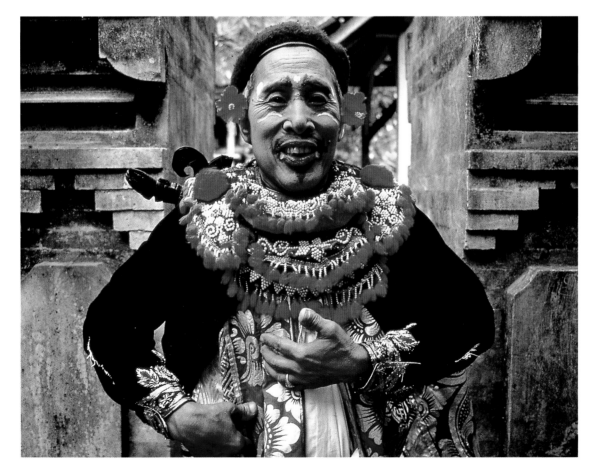

Above: These masked dancers have just performed a *telek-sandaran* dance, a classical version of an exorcism dance.

Left: The *topeng* masked dance-drama is renowned for its variety of masks and movements. *Topeng* performances often tell the stories of Balinese kings.

Facing page, clockwise from top left: These *legong* dancers perform a dance that dates back 300 years; Young boys sway through the graceful moves of the *gopala* dance. The dance was choreographed to honor Bali's cowherds; This is just one of the masks that versatile *topeng* performers use; A young solo *baris* dancer strikes a martial pose.

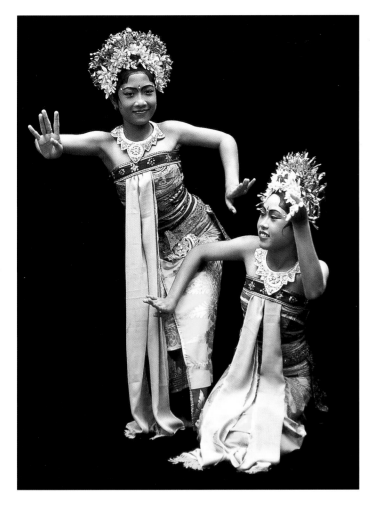

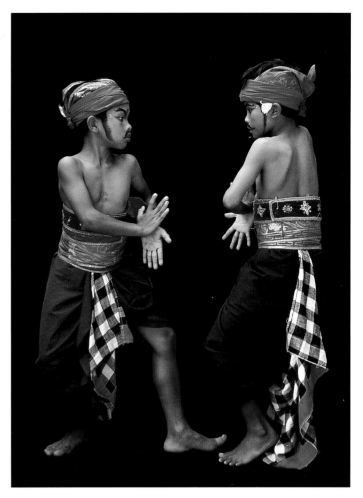

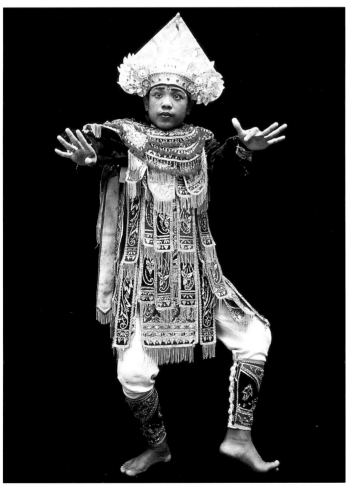

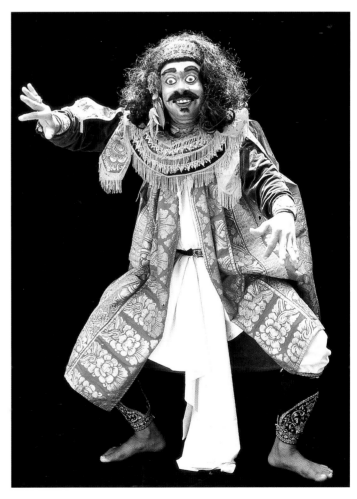

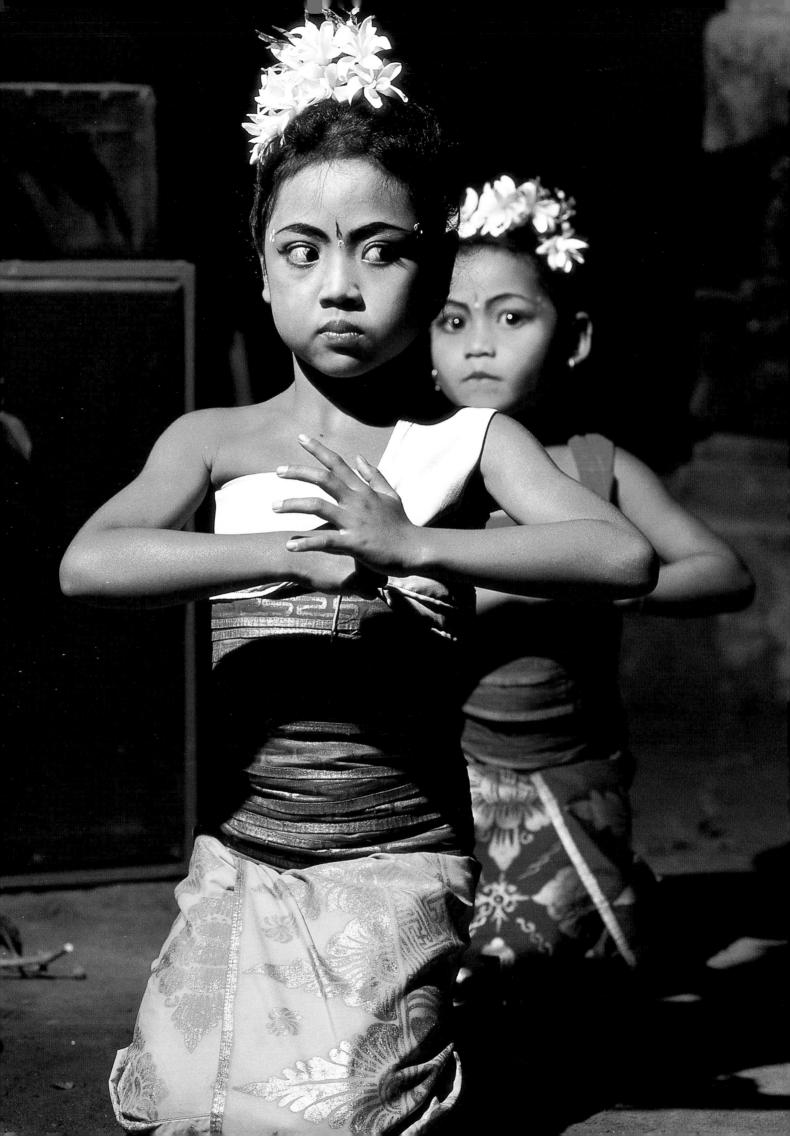

Left: Two toddlers peform with all the skill and concentration they possess. Dance training begins at an early age and requires years of rigorous training. At first, a teacher guides the girls through the movements, leading them by the wrists until the entire choreography is an indelible part of them.

Right: A young *legong* dancer prepares for a performance.

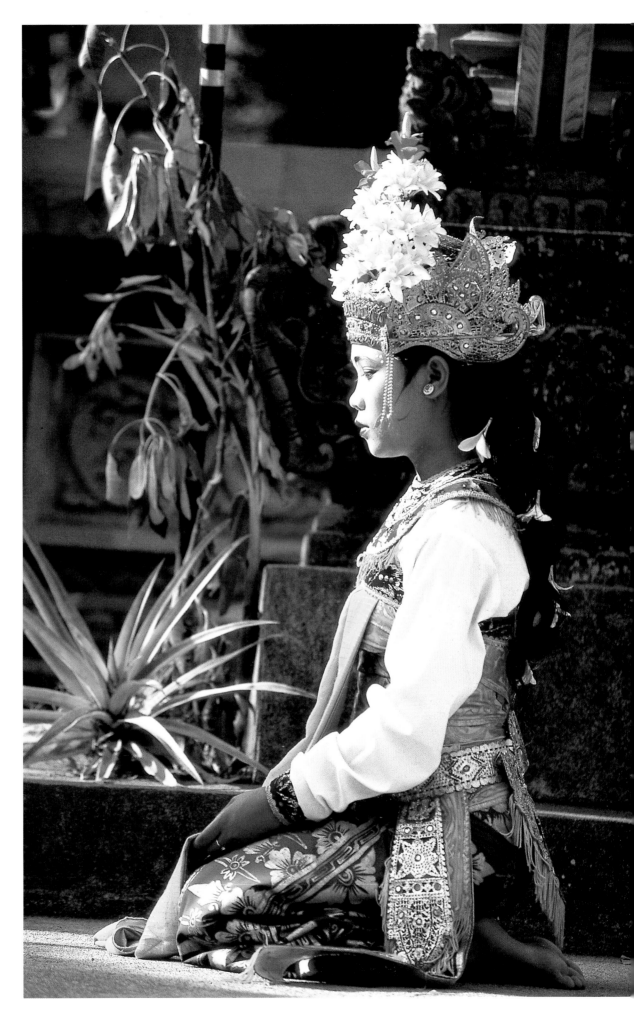

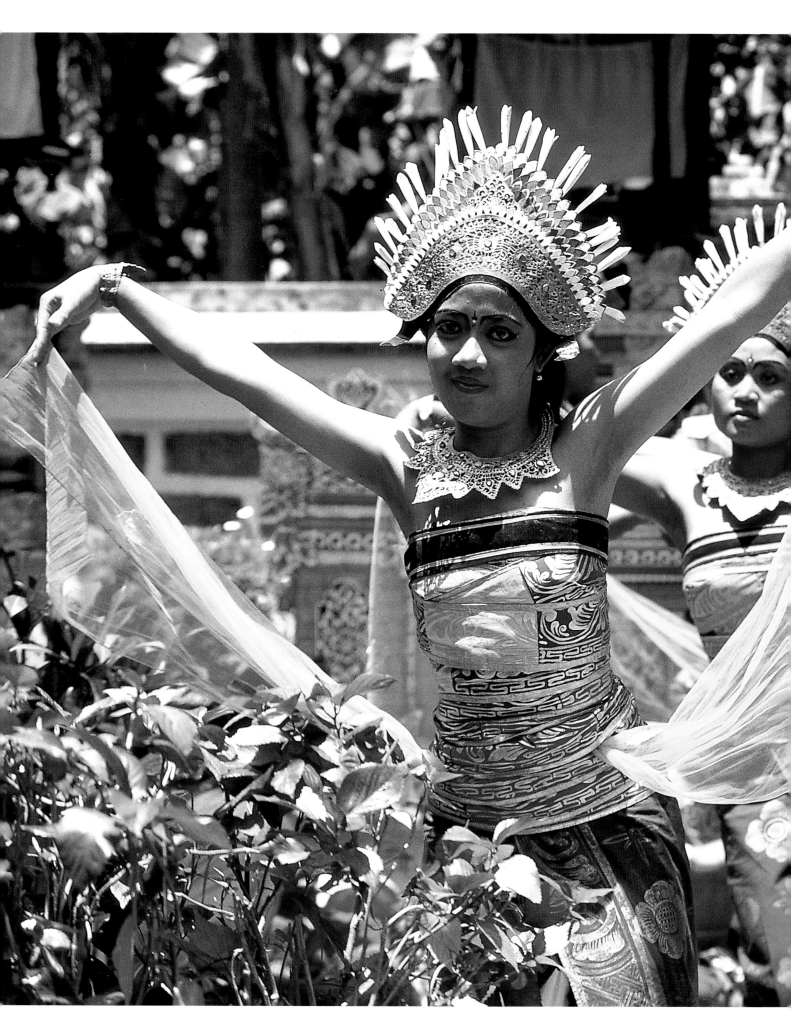

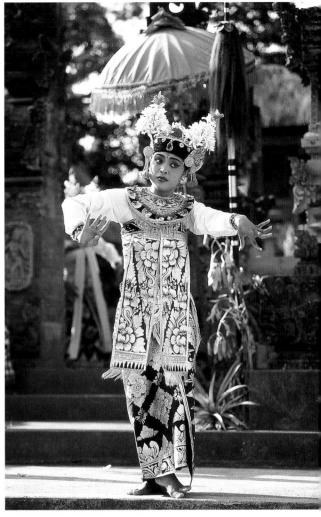

Above: Only girls perform the *legong*, considered by many to be the most exquisite form of Balinese dance.

Left: *Janger* dancers with remarkably florid headdresses move across a temple courtyard. The dance began around 1925 and was strongly influenced by Malay opera. It was also the first social dance in Bali where boys and girls could join together and have fun. The *janger* had a brief and glorious period of popularity, epitomizing the Balinese love of new things, but today it is performed mostly for tourists.

Pages 70–71: The *kecak* is a dance with large groups of men singing, chanting and moving together with the music. The best known *kecak* accompanies stories from the Ramayana, the great Hindu epic, and trance dancing is frequently an element of these performances. It is also known as the Monkey Dance, named for an episode where the male chorus plays a jabbering band of monkeys in thrall of its leader, Hanuman, the Monkey King.

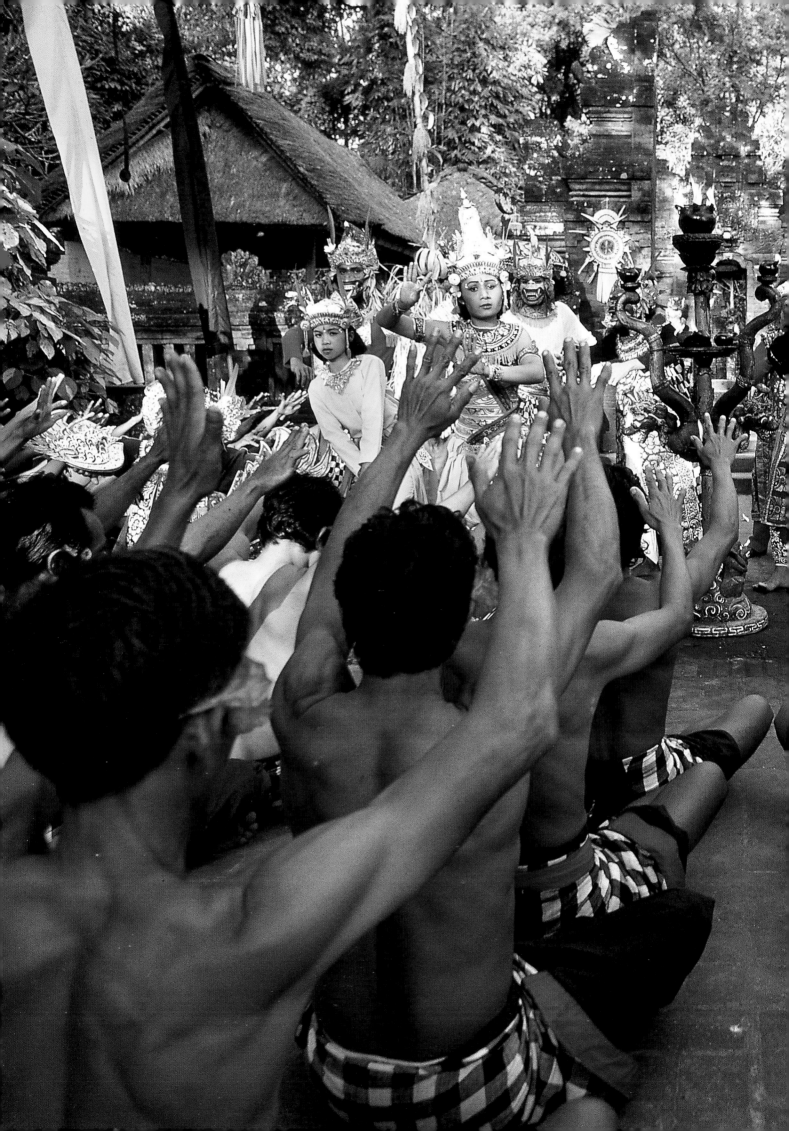

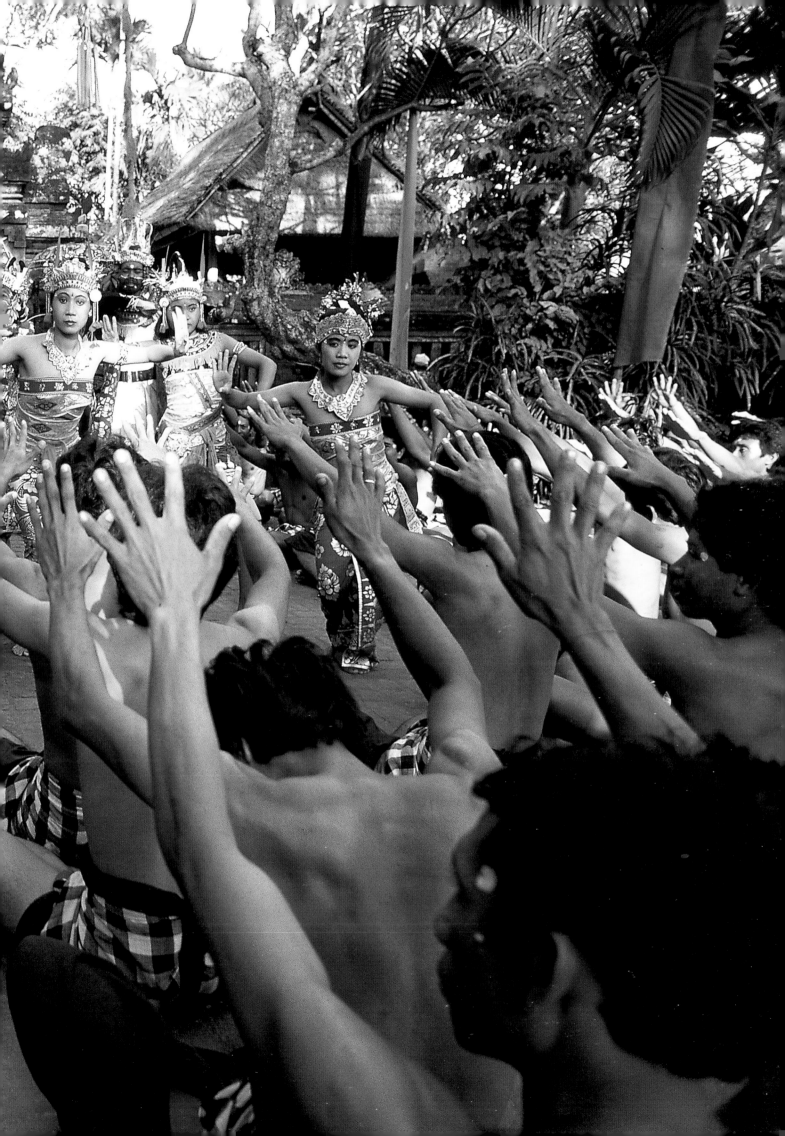

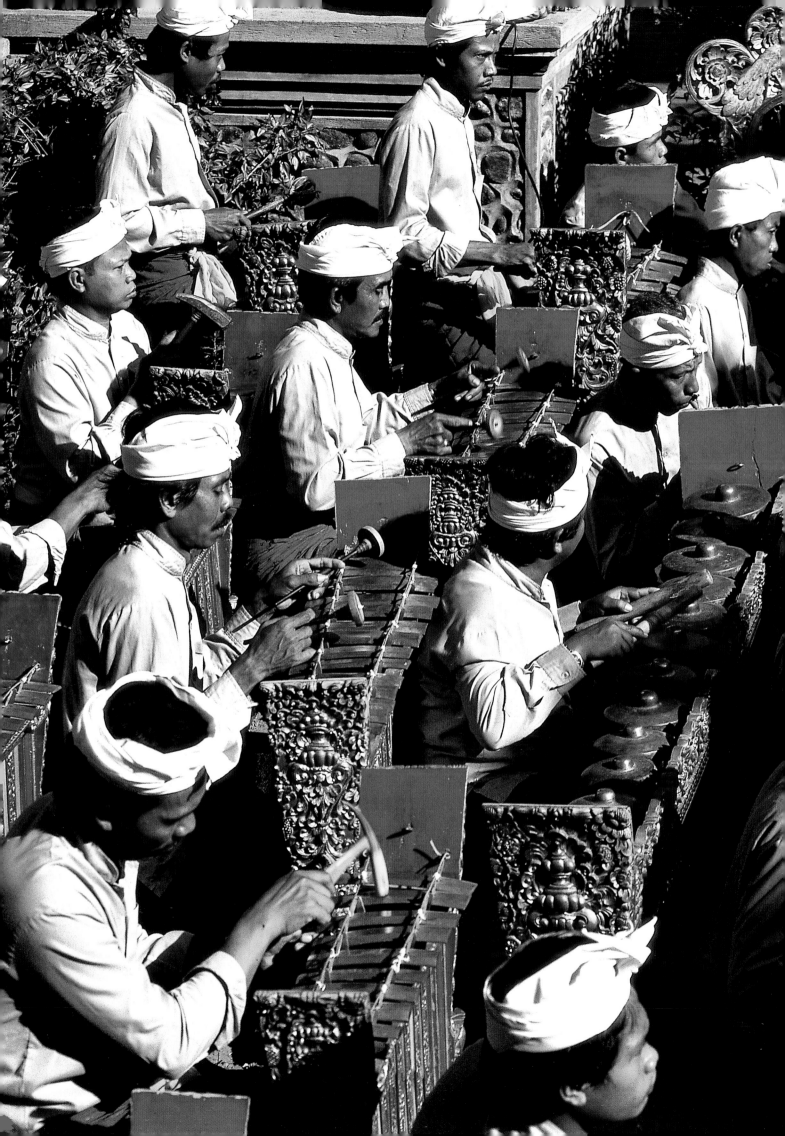

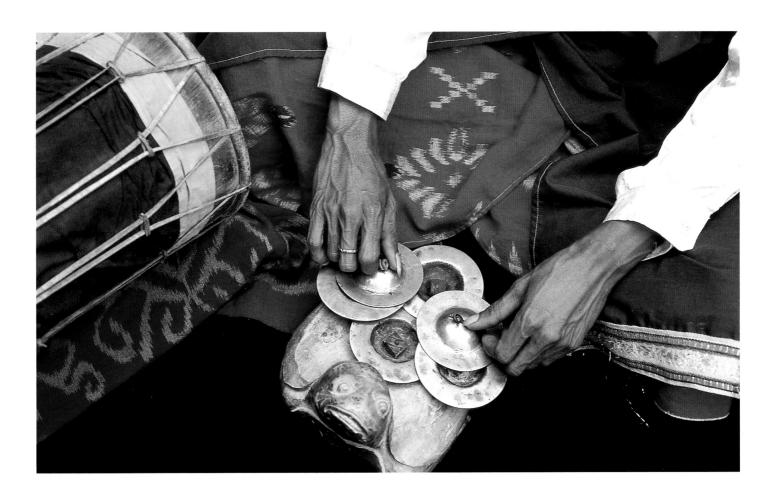

The gamelan orchestra (opposite), made up primarily of metallophones, numerous suspended gongs and many types of cymbals (above), is an indispensable part of Balinese creative life. Most villages have at least one or two gamelan orchestras, and this hypnotic music with its subtle beauty can be heard throughout the island nearly every evening. The bamboo flute (right) is used as a lead for the melody.

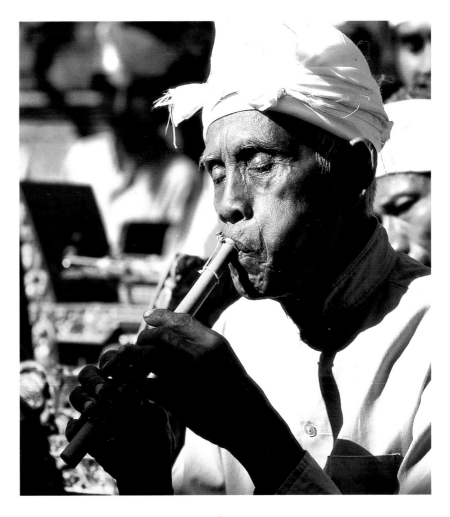

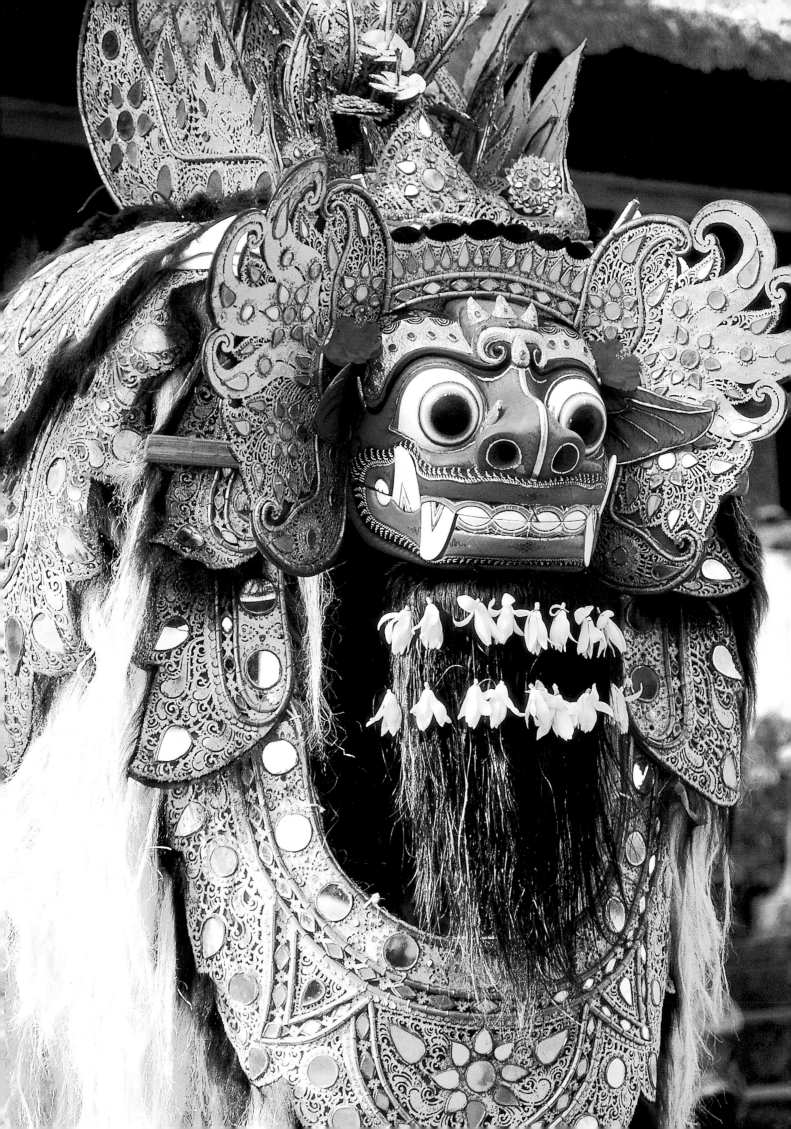

Bali's most powerful drama revolves around the confrontation and clash of two mythical creatures, Barong (left) and Rangda, personifications of the forces of good and evil. Barong represents sunshine, medicine, life and light, and likes to dance for the sheer joy of entertainment. But Barong's playfulness is interrupted by the appearance of Rangda, hideous witch and Queen of Death. In the climactic struggle that ensues, trance dancers rush to Barong's aid, only to have their daggers turned against them by Rangda's evil magic (right). Barong's own power prevents the daggers from piercing flesh no matter how the entranced men try to kill themselves. In the end the dancers are slowly brought out of trance with the aid of Barong's beard, the center of his power. There is no ultimate winner in this cosmic struggle; only a temporary victory and evil invariably engages in battle again.

Pages 76–77:
The Barong is a mythological lion-beast that represents the forces of good. Barong are protective spirits for Balinese villages and these sacred masks are kept in a special place within the temple and given daily offerings.

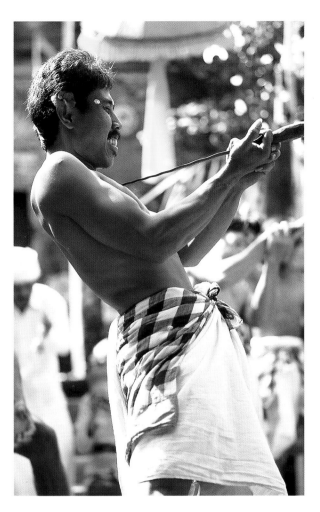

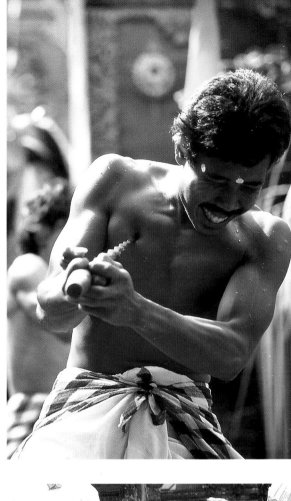

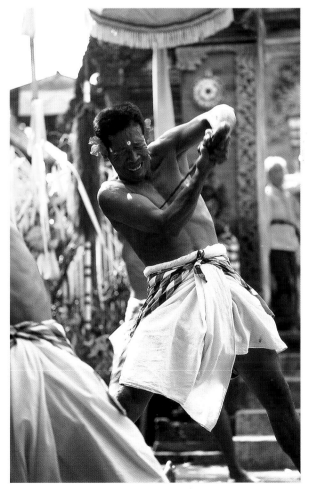

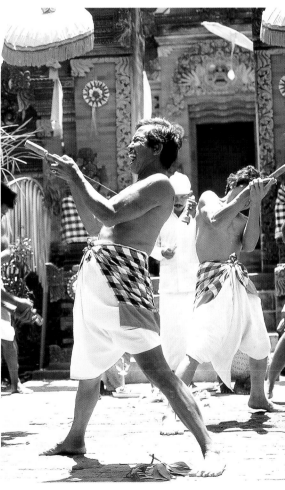

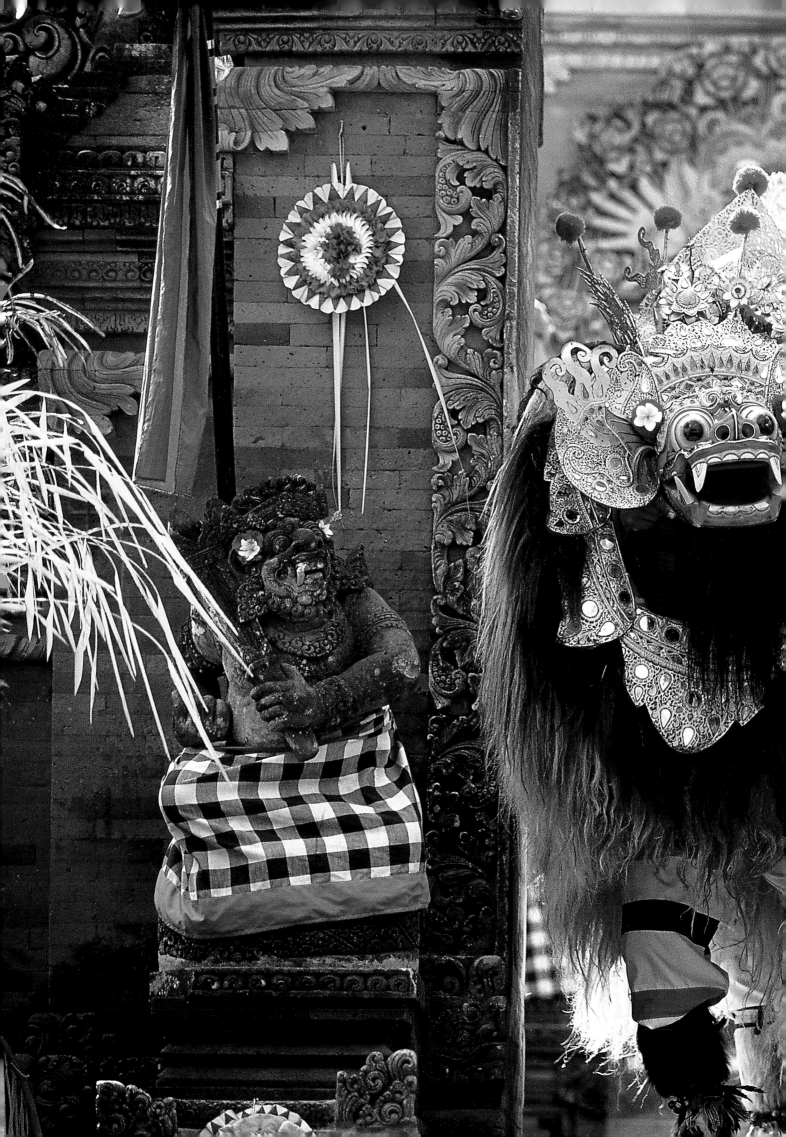

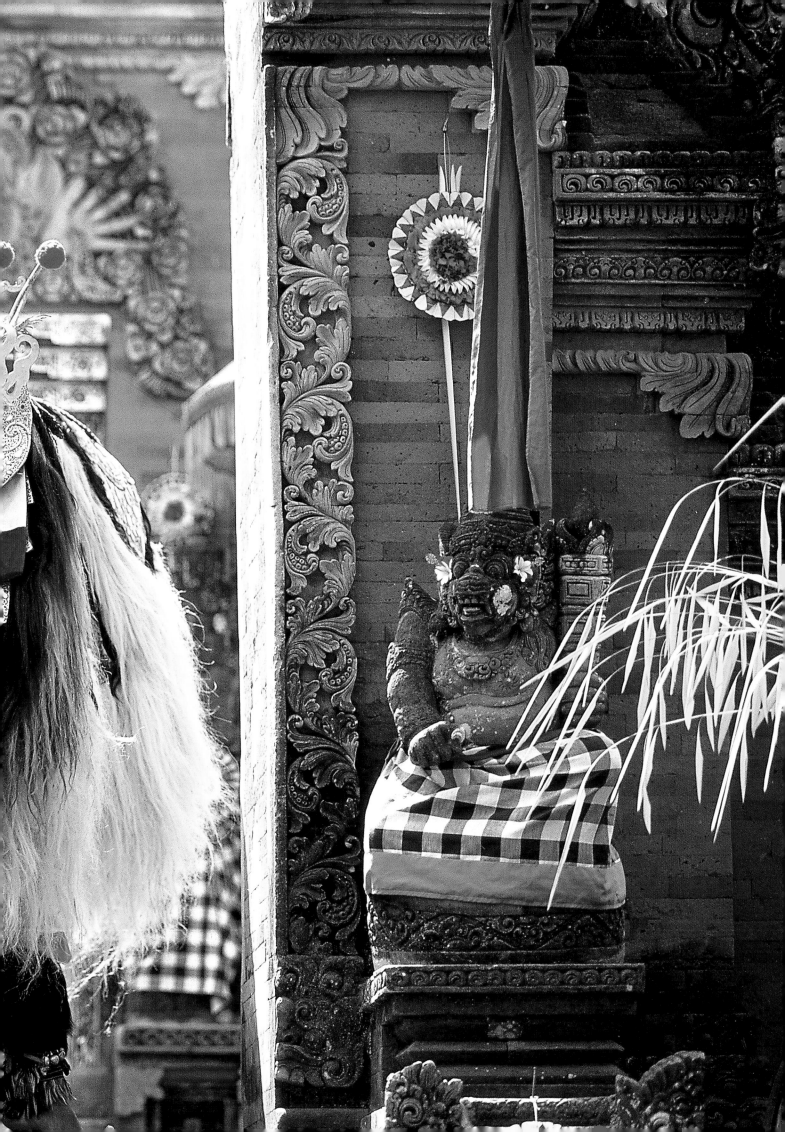

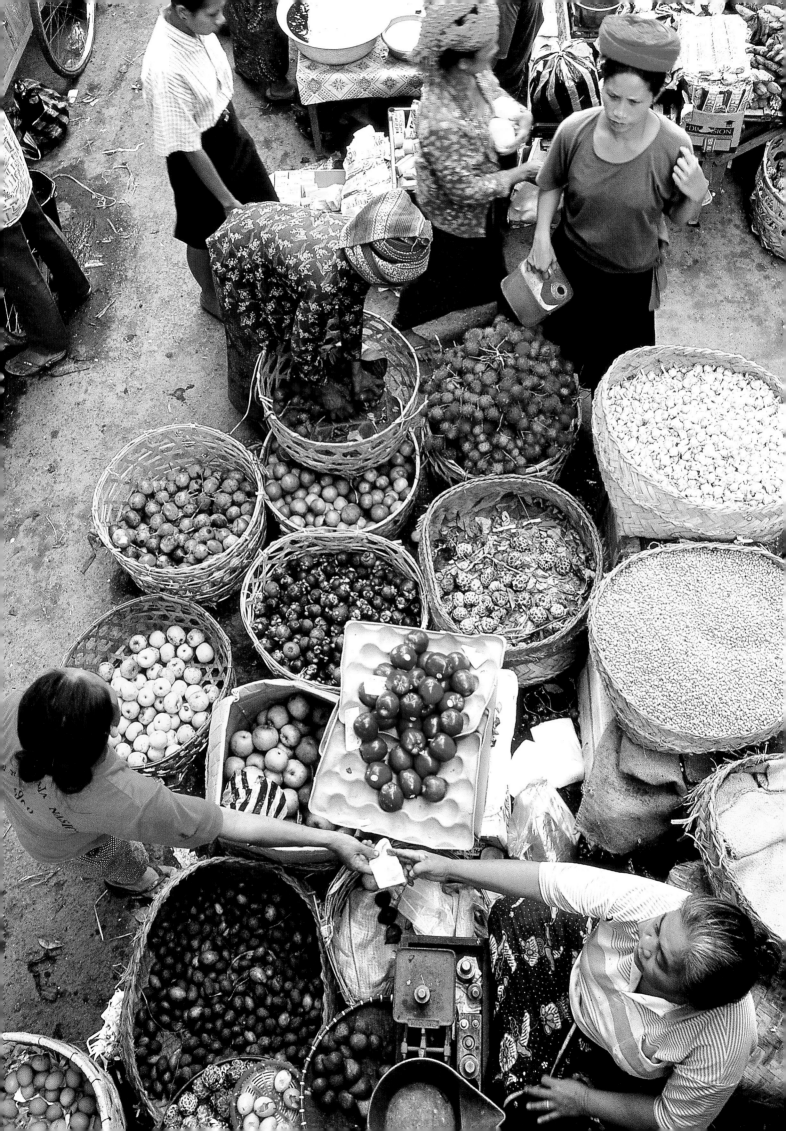

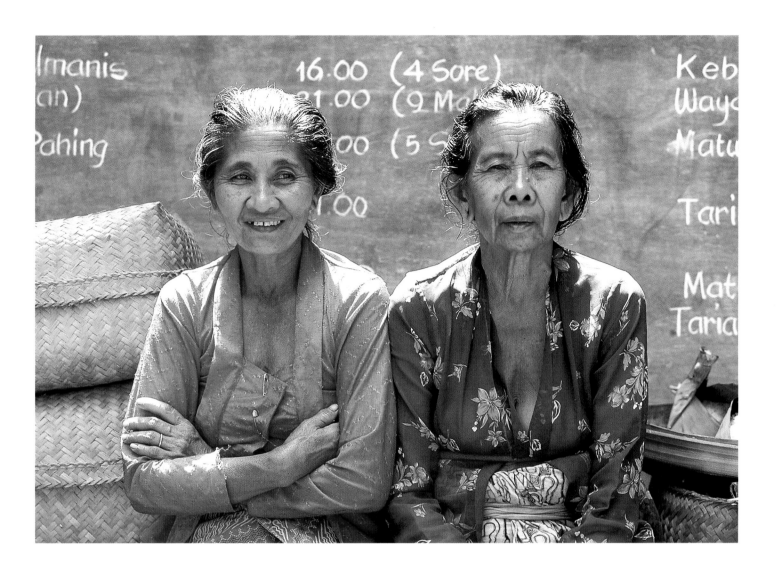

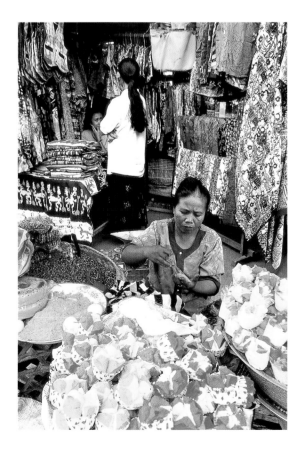

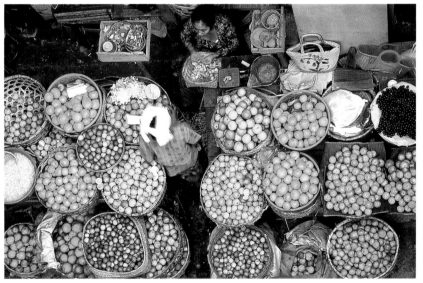

Every third day is a major market day on Bali. Traditionally, women control the goods and do nearly all the buying and selling. They stream into towns in the morning and by noon when the activity is at its height, the marketplace is filled with exotic smells of pepper, cinnamon, mace, coconut oil, dried fish and fried sweetbreads. These two women (top) are relaxing at the end of a busy market day.

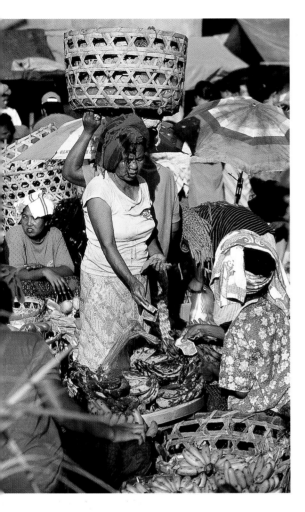

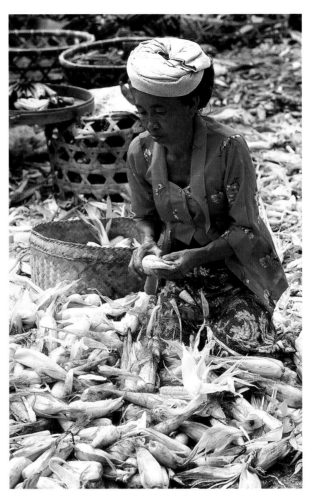

Market days in Bali are a riot of color and noise and are popular among locals and tourists. Bargaining is the order of the day as prices are not fixed, and vigorous haggling is engaged in good-naturedly by all.

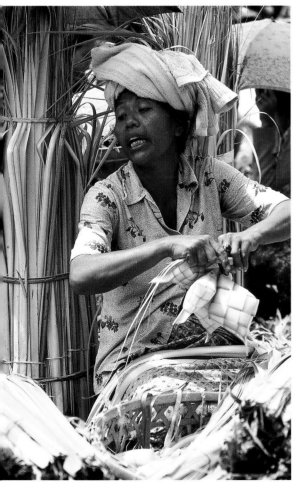

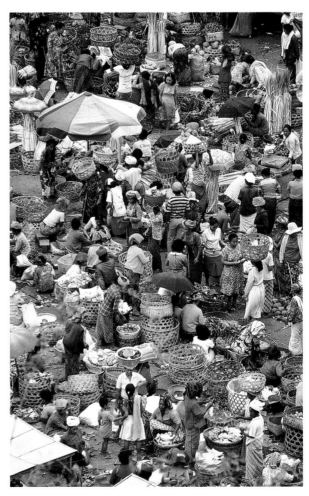

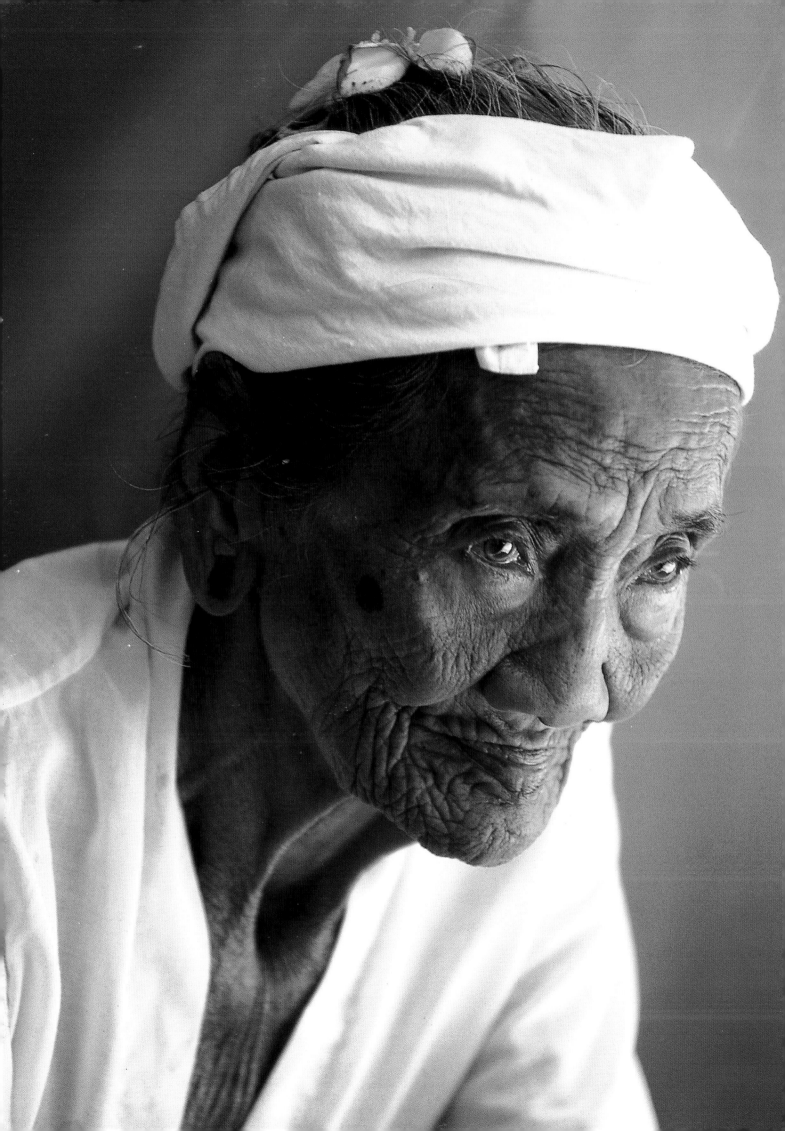

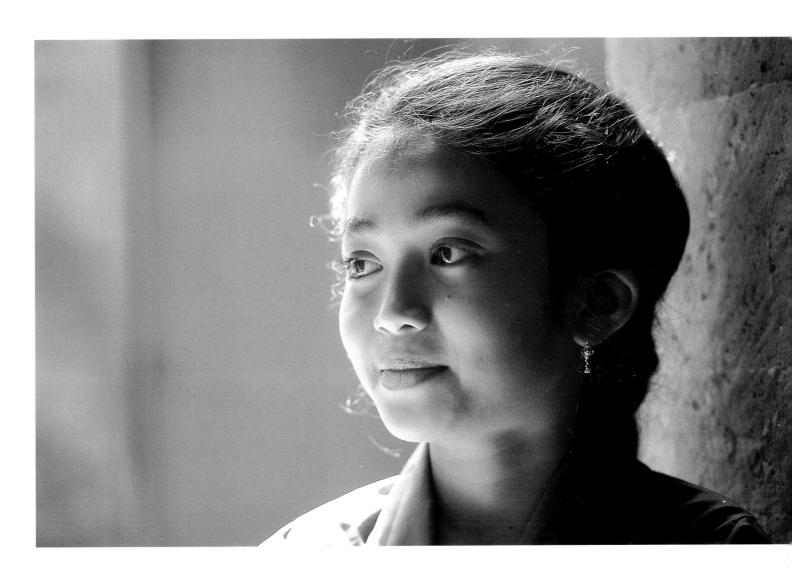

Bali has a population of over three million inhabitants. The Balinese people are known for their gentleness, humor and creativity. In older times they were also known as fierce and hot-tempered warriors, and this sense of pride is still much in evidence today.

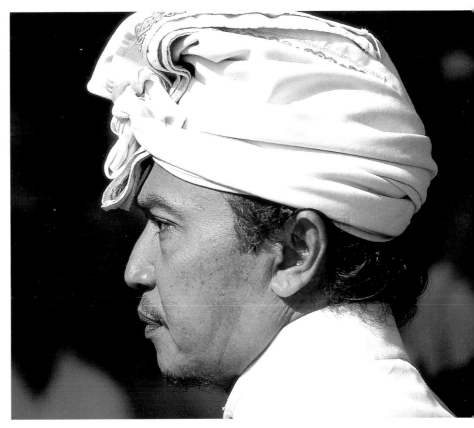

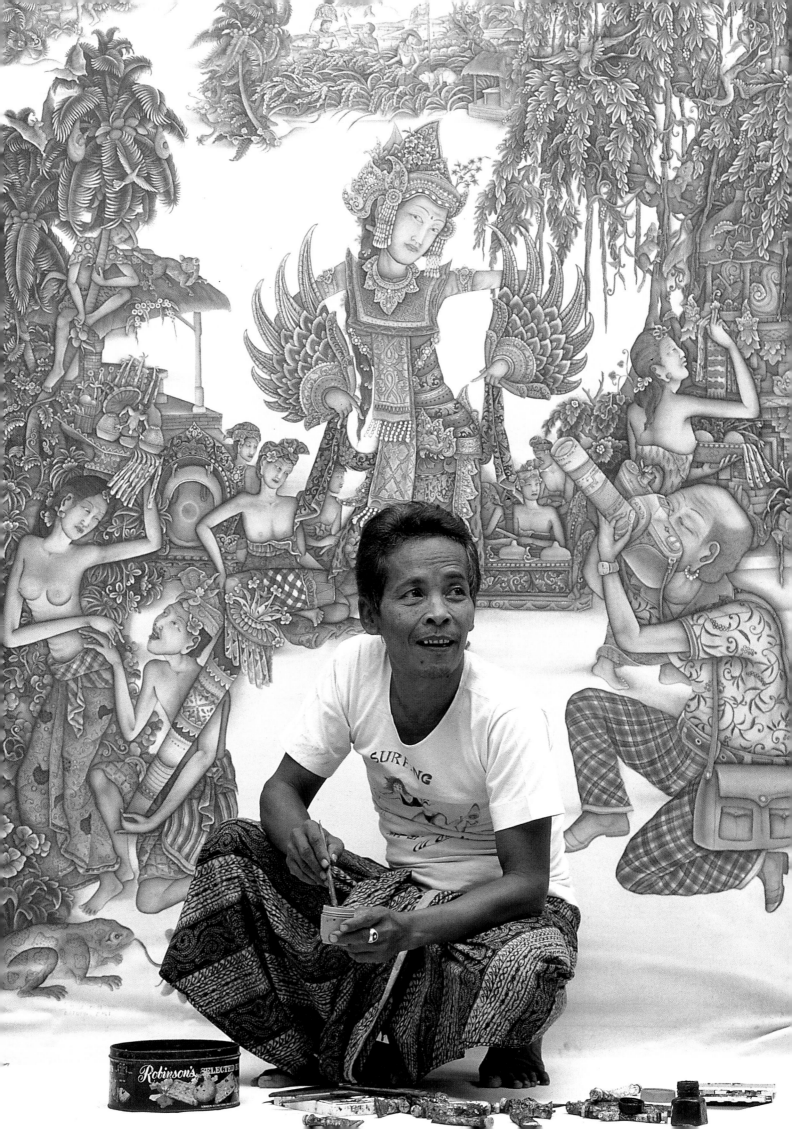

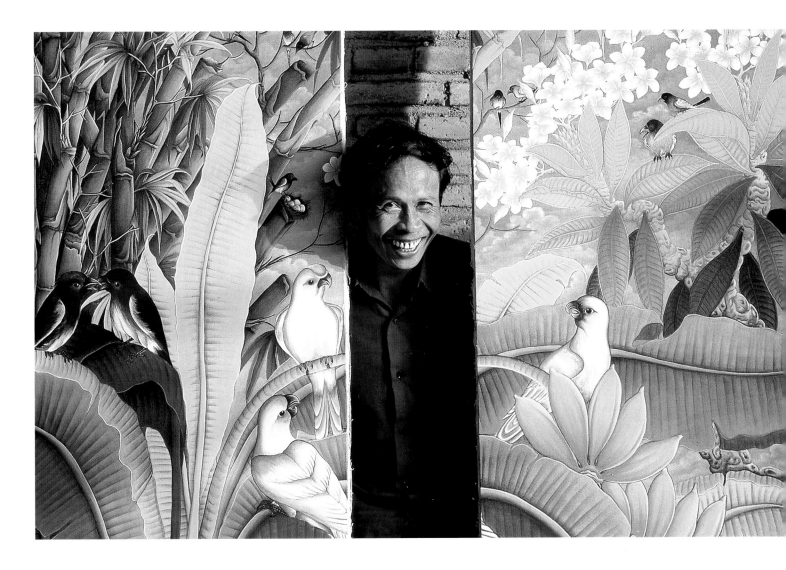

Above: An artist emerges from behind two panels of his forest painting. Painting in Bali went through a period of rejuvenation in the 1930s when it was strongly influenced and encouraged by European artists. They introduced new materials, themes and treatment of light and helped liberate painting from static, traditional forms.

Left: I Madé Budi takes a break from painting a life-sized artwork. Budi's paintings combine traditional religious and historic themes with modern subjects.

Right: This stunning detail is from one of Budi's paintings, entitled "The 1906 Badung Puputan," which recounts the invasion of Dutch forces and the mass ritual suicide of the Denpasar courtiers.

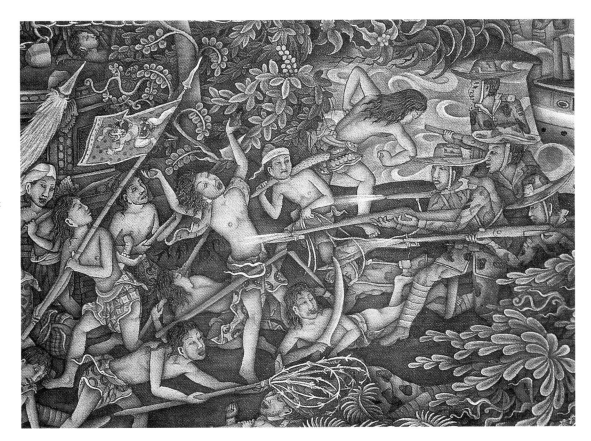

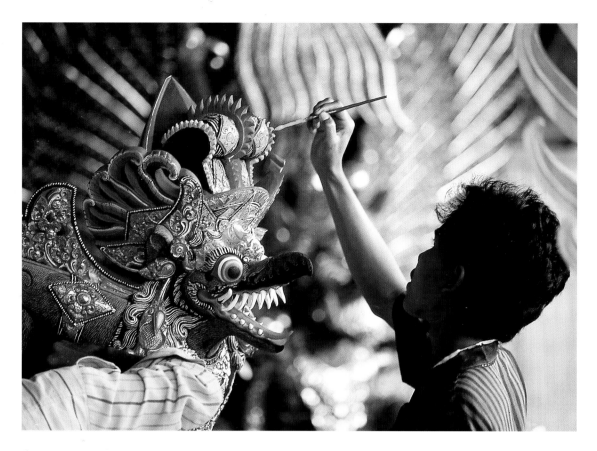

Woodcarvers add the finishing touches to their creations (left and below), while a craftsman proudly displays a gigantic hand-carved garuda bird (right). Craftsmen traditionally carved only religious objects, though over the years, the range of subjects produced has evolved to suit tourists' tastes.

Pages 88-89: A stunning array of Balinese antiques and artefacts may be found in curio shops around Bali—including old masks, batik cloths and statues. Although many of the Balinese antiques on sale now are actually reproductions, genuine items can still be obtained from specialist dealers.

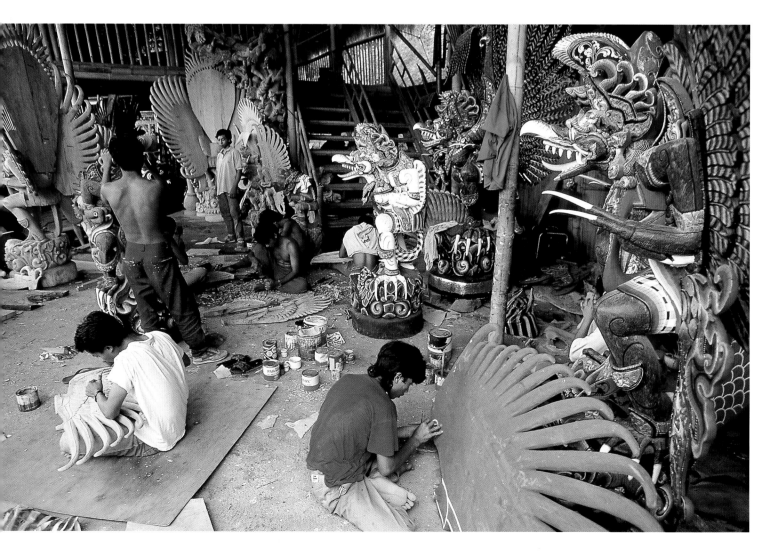

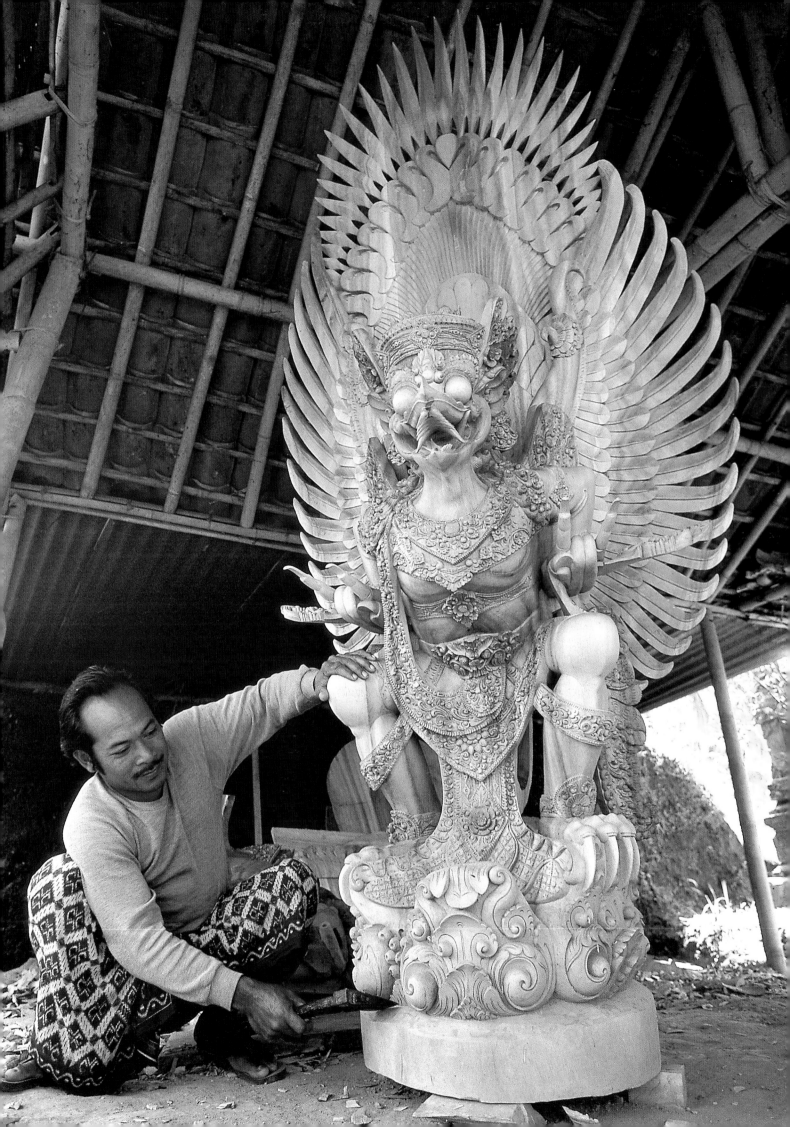

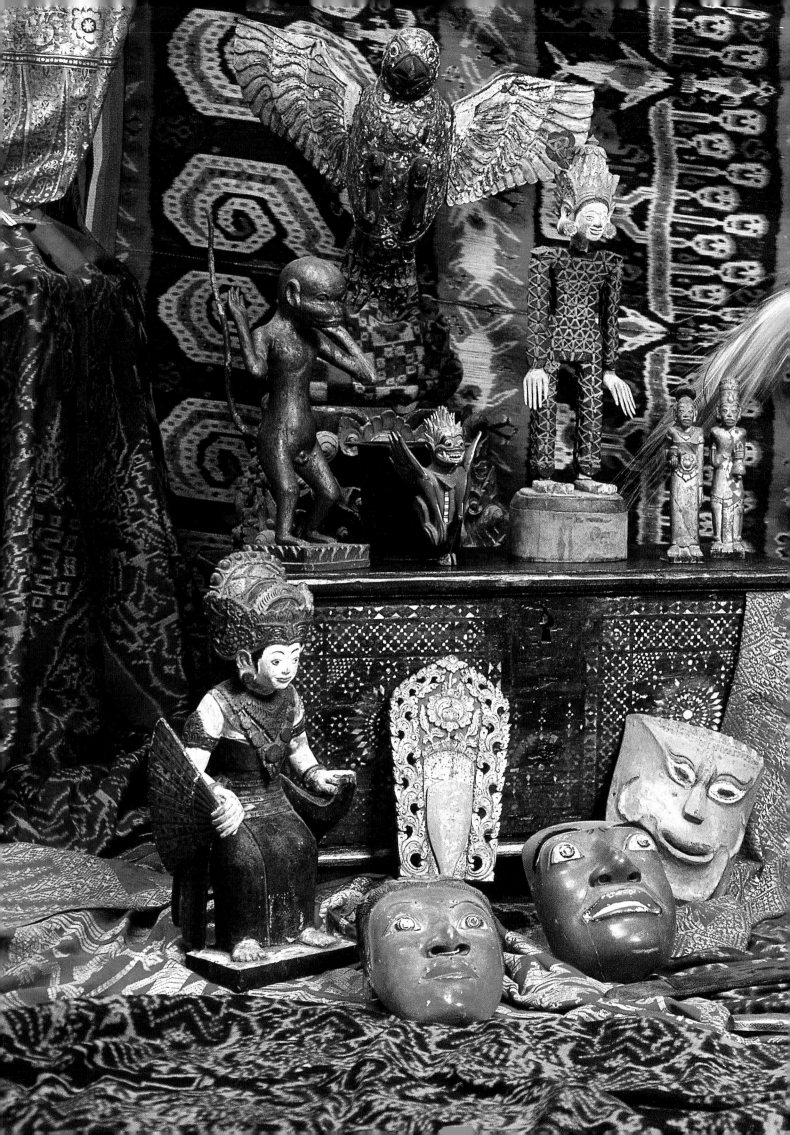

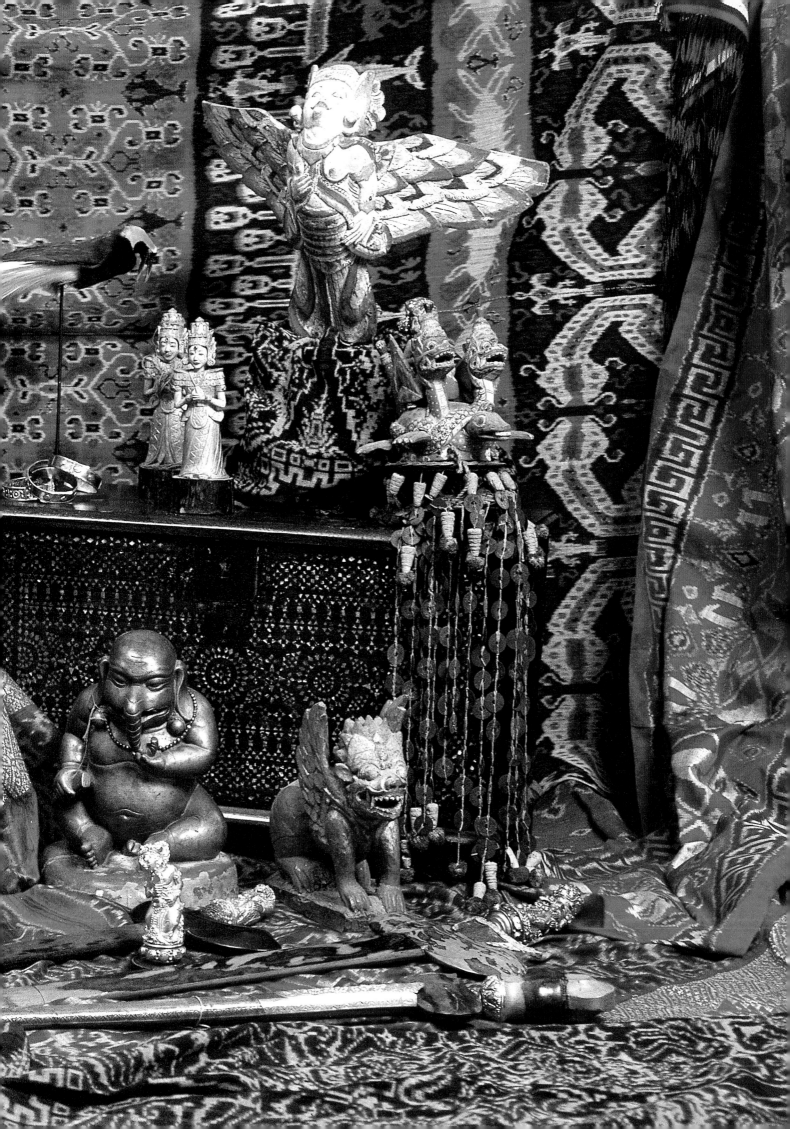

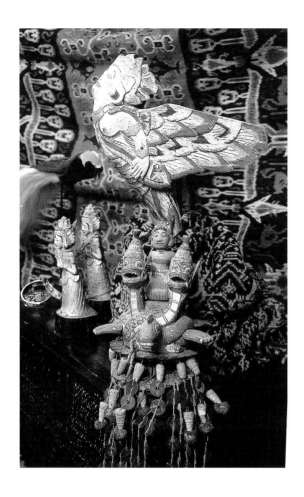

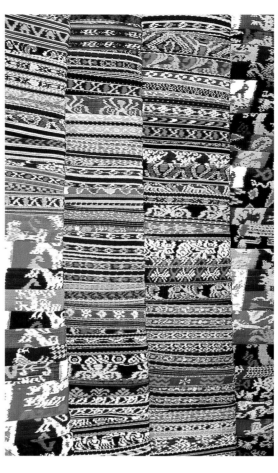

Far Left: This selection of Balinese antiques includes a pair of gold-painted *pratima* temple god and goddess that have been said to induce a state of trance in people.

Left: Textiles on display at a market stall. Traditional Balinese fabric designs once indicated a person's caste, age and sex, and are still worn during rituals. The fabrics shown here are Sumba and Flores *ikats* produced for the tourist market.

Right: A mask-maker from Mas shows off one of his works. In former times the famous artists of this region worked solely for the temples and royal courts. These days secular art is widespread and masks can be made for decoration and sold commercially.

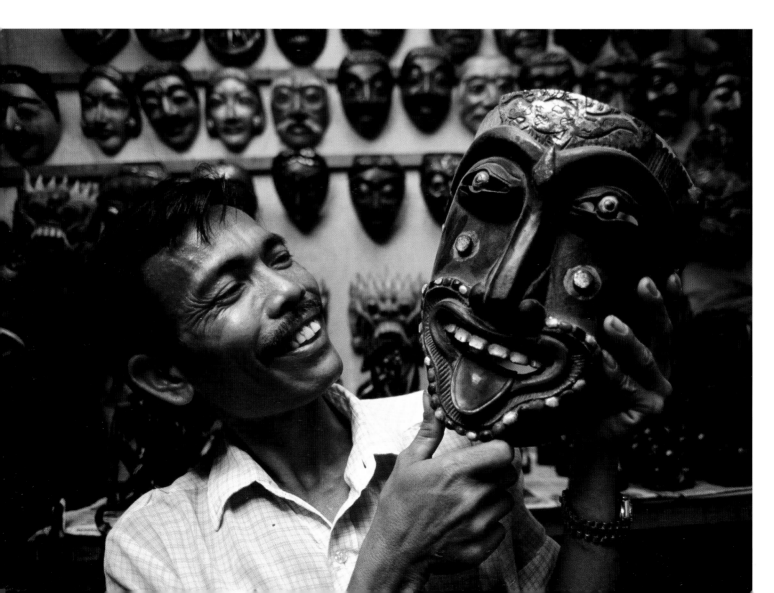

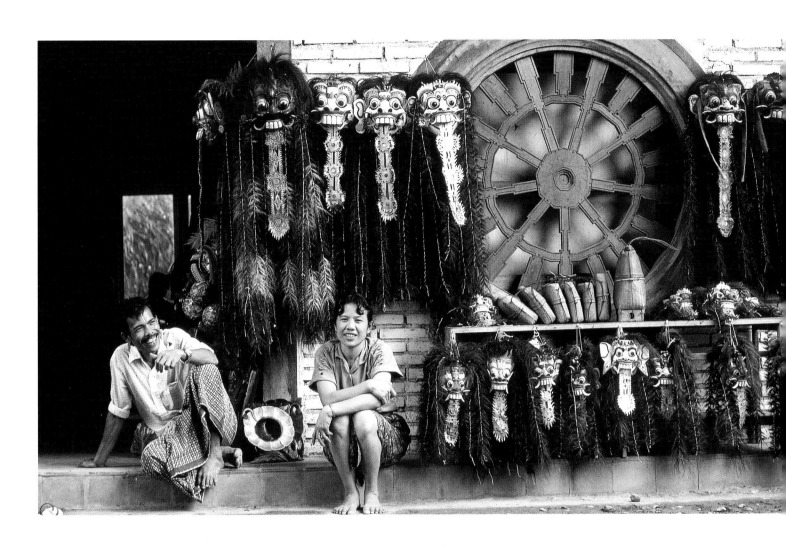

Rangda masks (above) and Javanese *wayang golek* puppets (right) on sale at a market in Bali. Such handicrafts are widely available on the island.

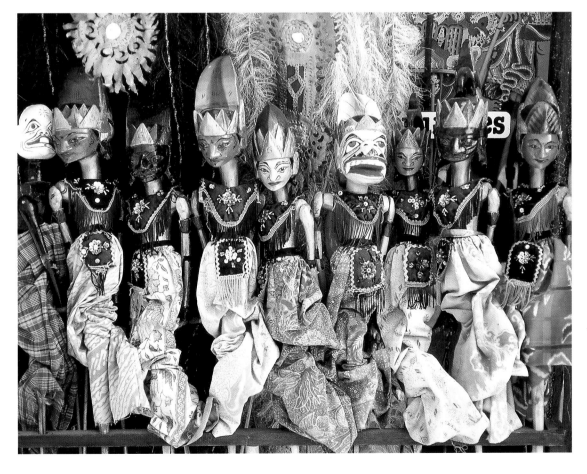

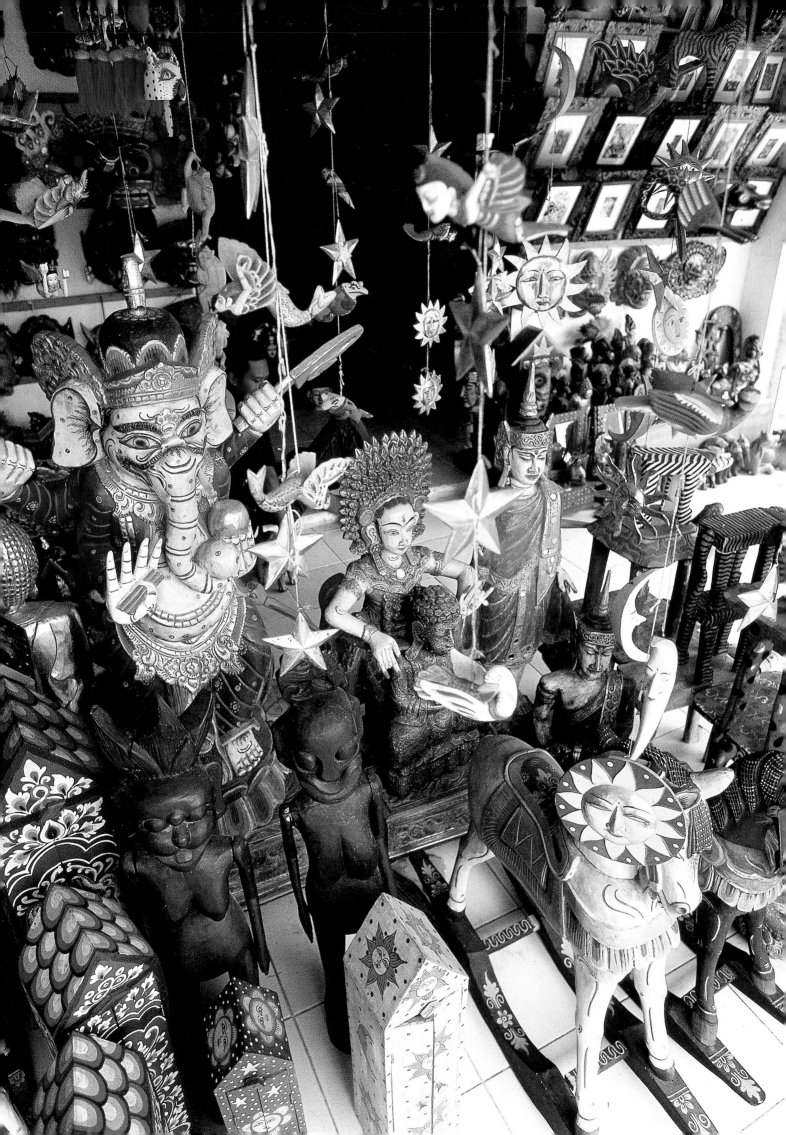

Almost all Balinese are proficient in some form of art and a rich variety of handicrafts, from handwoven baskets (right) to woodcarvings (opposite) may be found at market stalls throughout the island

Pages 94–95: Fishermen in outrigger boats head out to sea along the east coast of Bali in search of the day's catch.

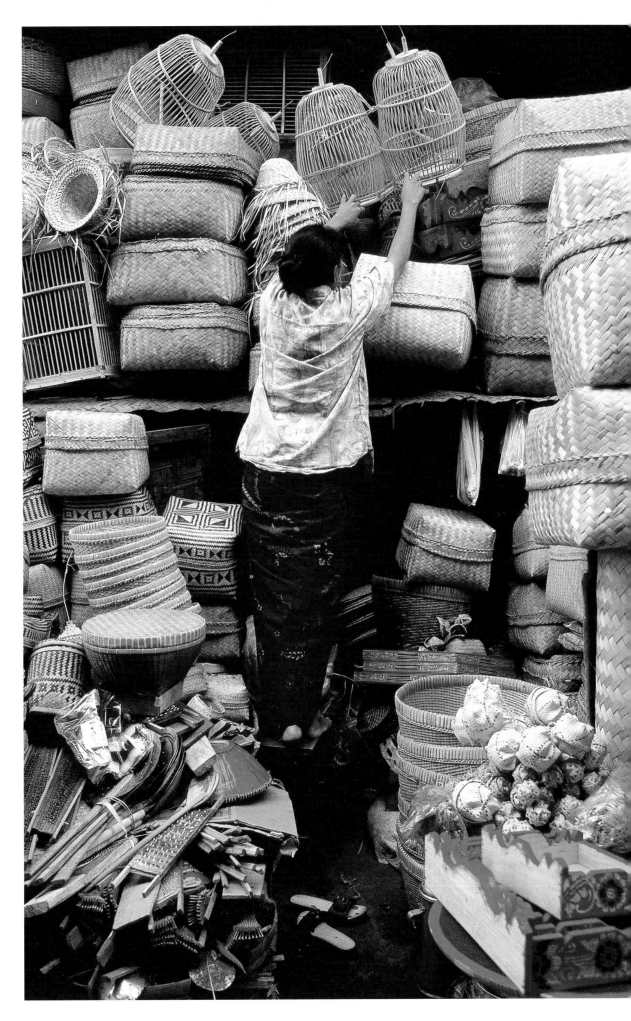

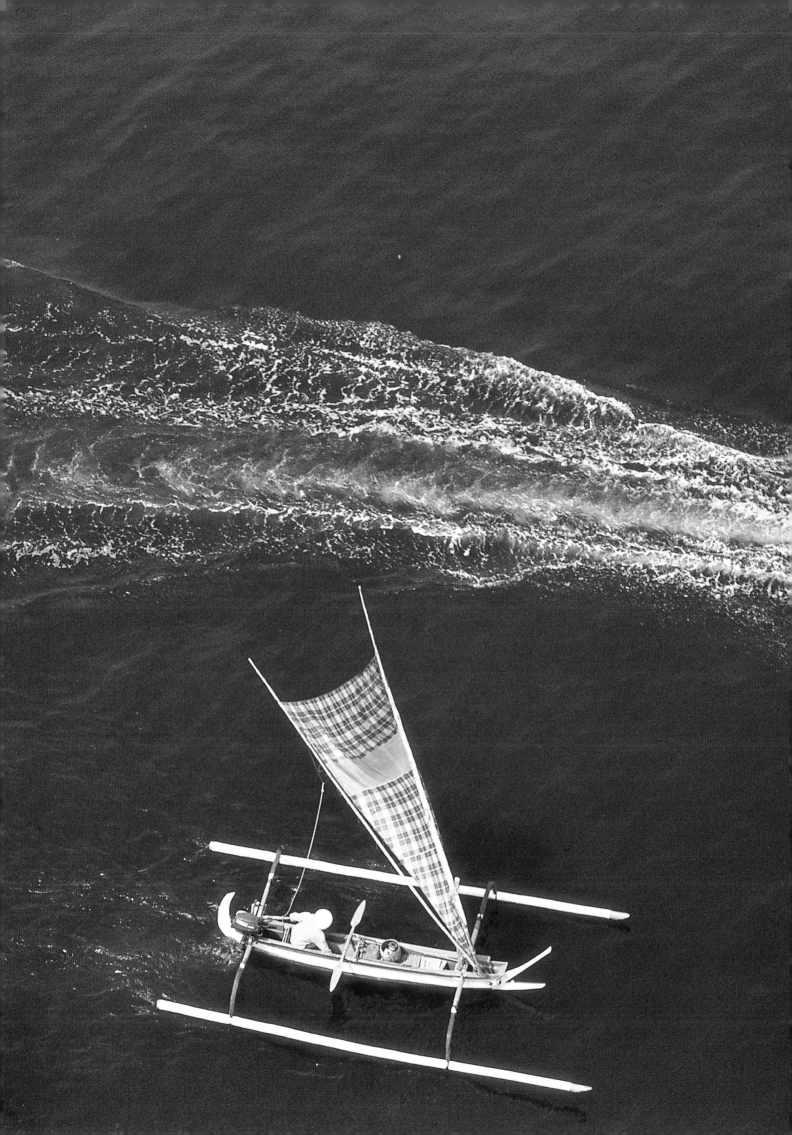

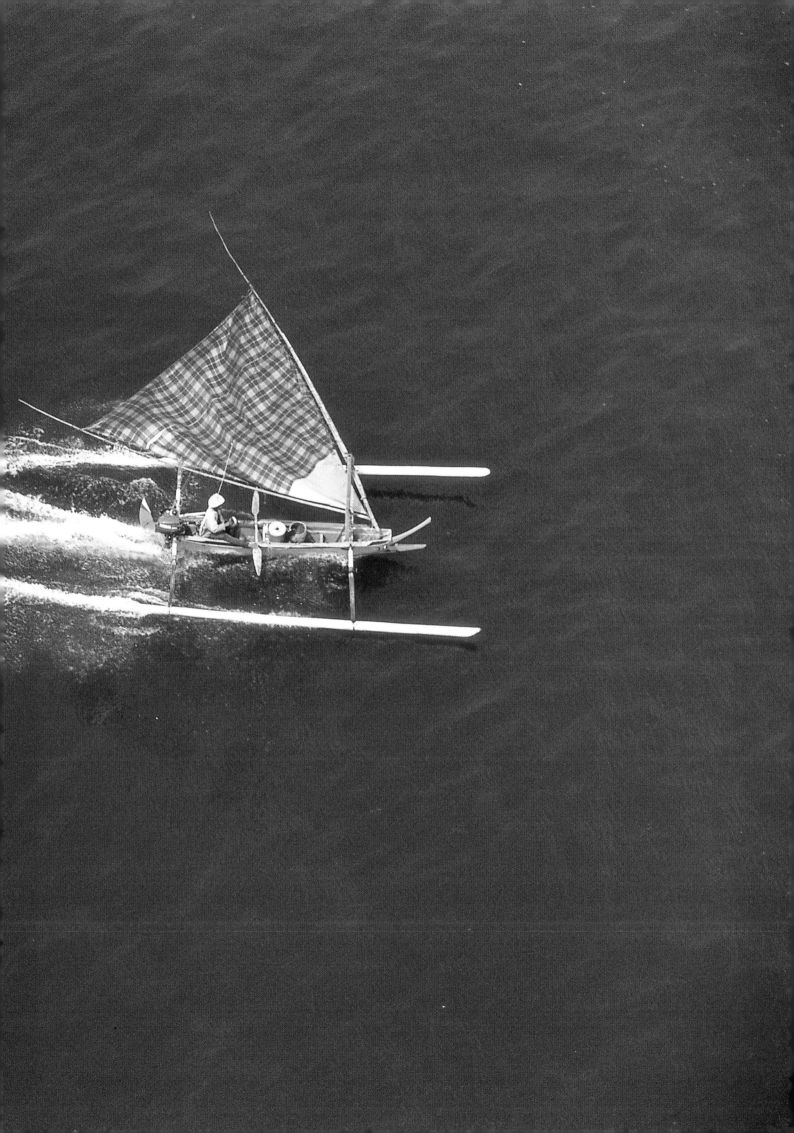

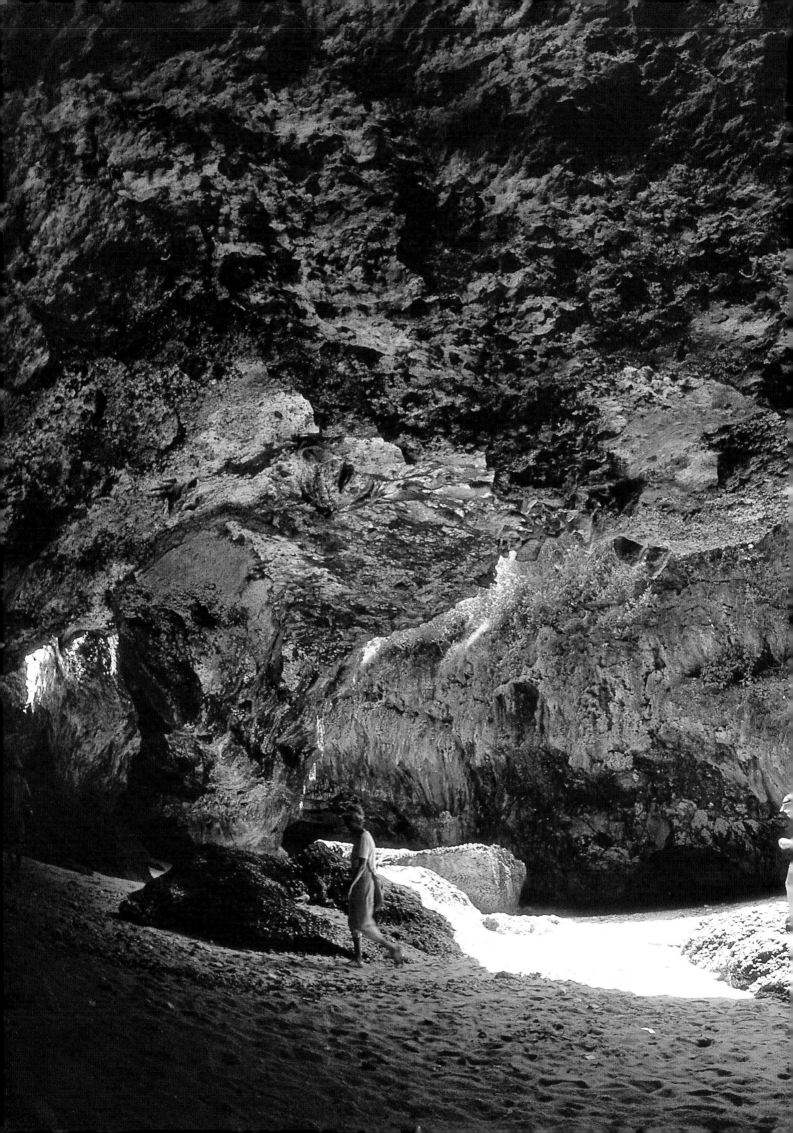

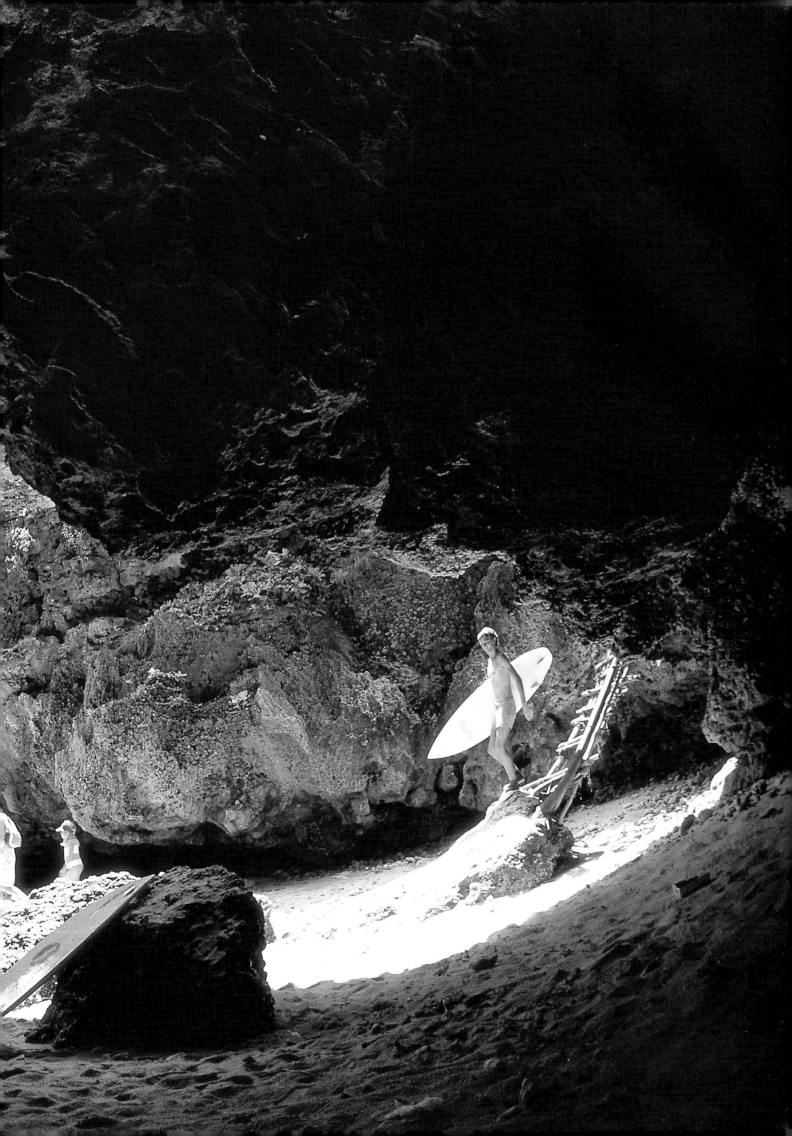

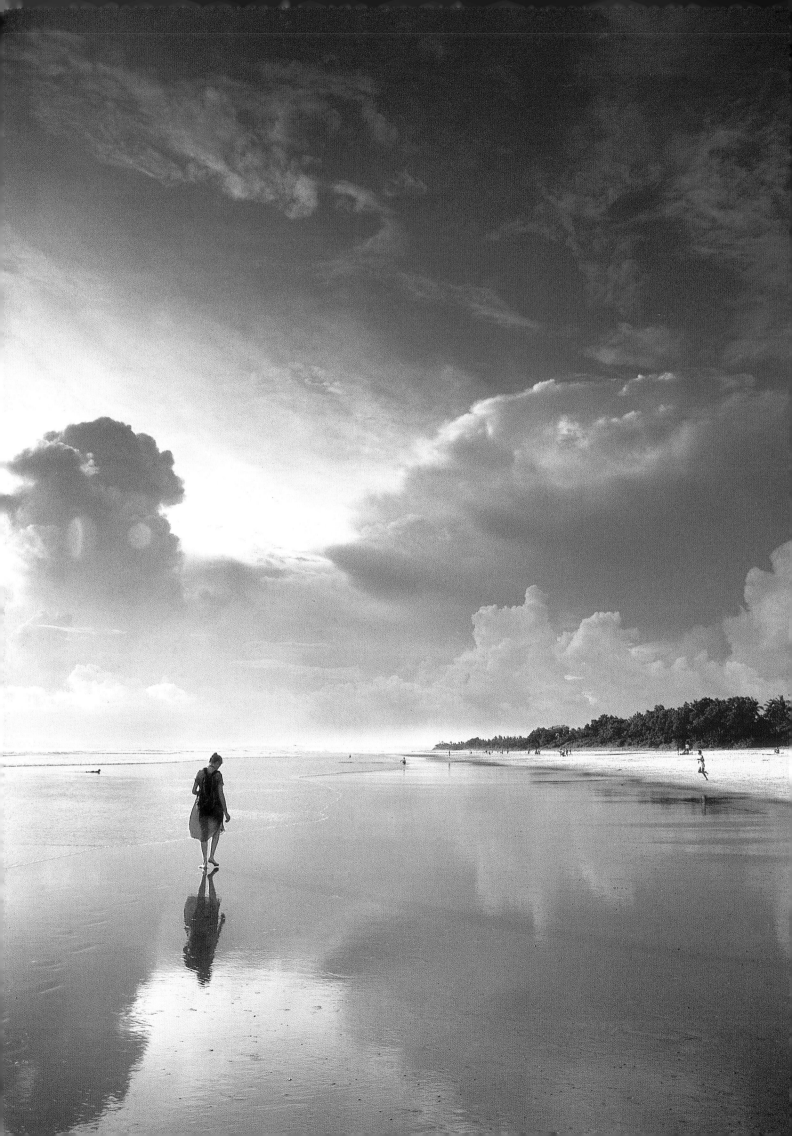

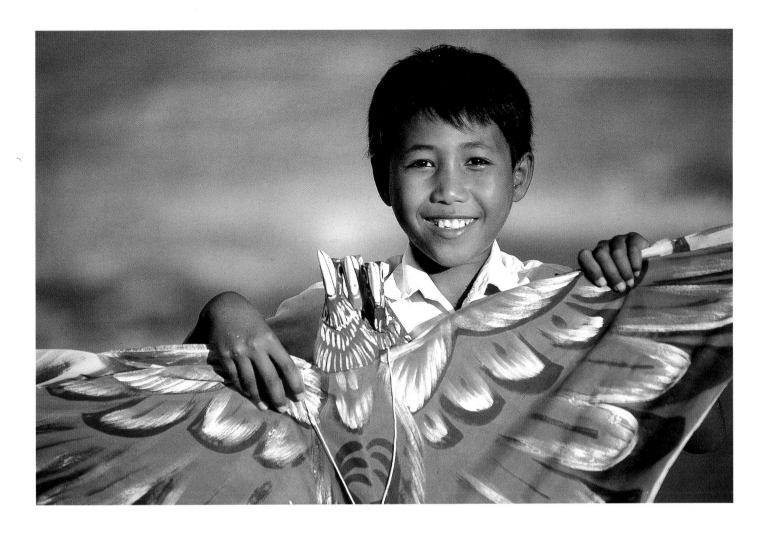

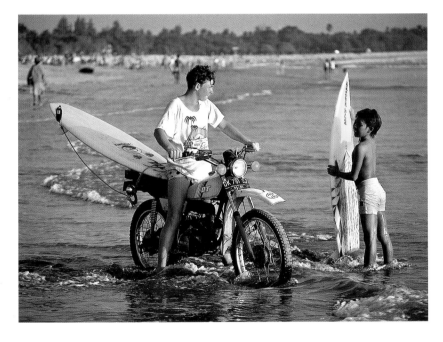

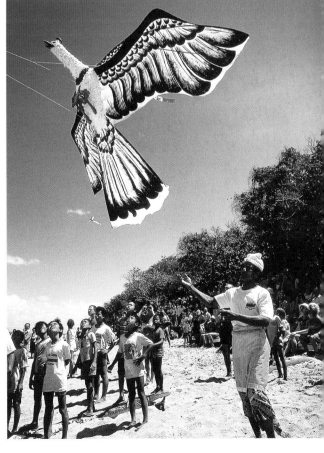

Left: Clouds pile up along the coast as a solitary walker shares in the peaceful end of a day.

Above:
A young traveler chats about surfing with a local boy.

Top and right:
Balinese and tourists alike love the kites and kite festivals along the beaches.

Pages 96–97: For more than 50 years tourists have been coming to Bali to play, to relax, to learn and to share in the special magic of the island. This family is making its way past the limestone caves of Ulu Watu.

The Four Seasons Resort at Jimbaran Bay is one of several luxury resorts that have opened in recent years. Guests stay in Balinese-style villas offering spectacular ocean views.

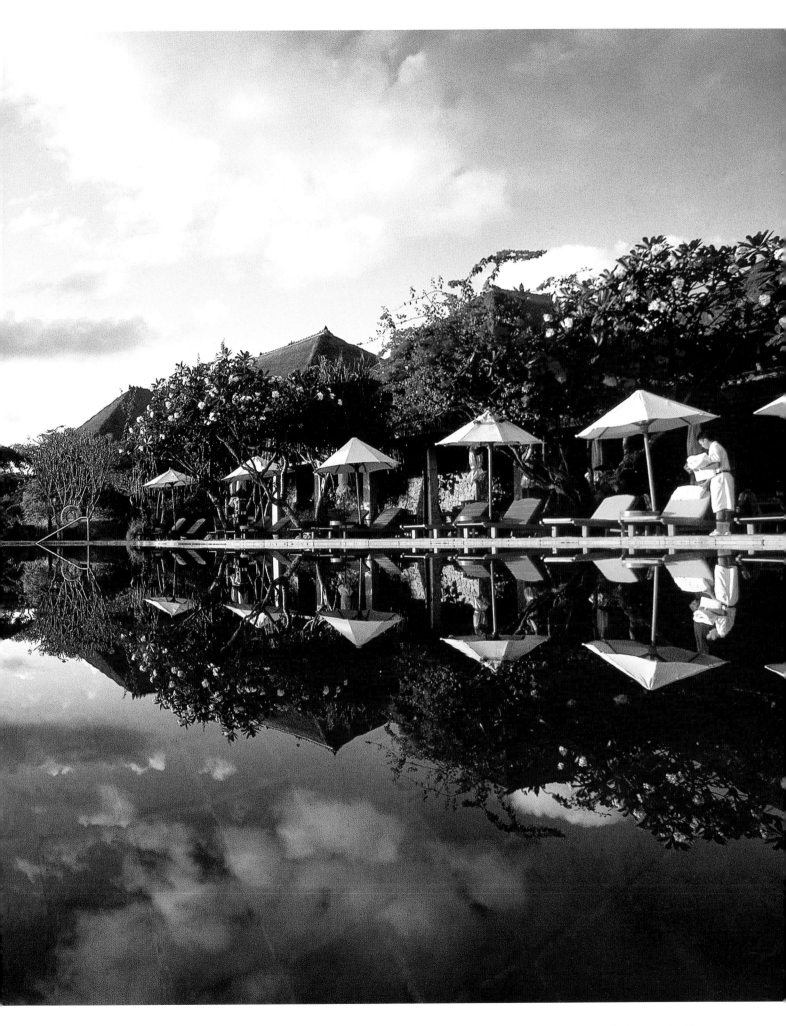

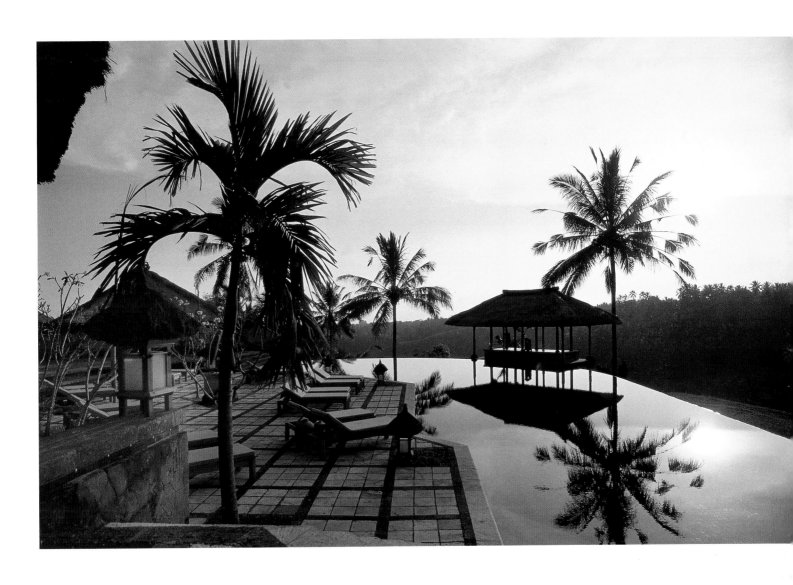

Travelers looking to be pampered in lush Balinese-style settings are spoilt for choice. The Amandari (above), Hotel Tugu (far right), Four Seasons Resort Bali at Sayan (right) and Kamandalu Resort & Spa (left) are just some of the luxury hotels and spas that offer serene holiday settings in Bali.

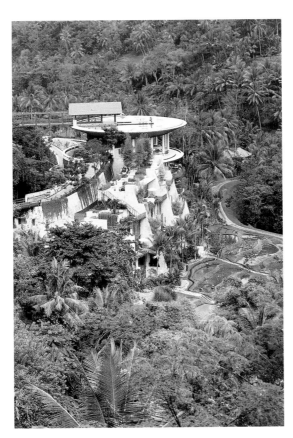

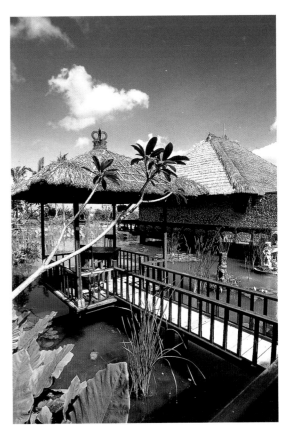

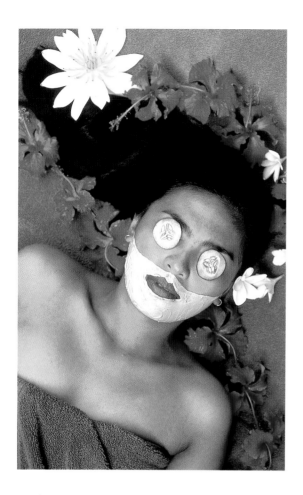

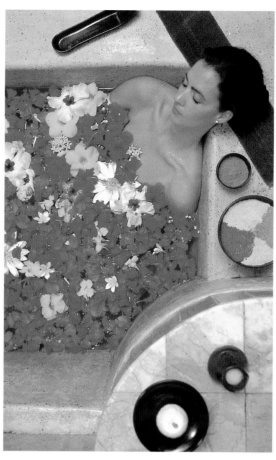

Left: The Kamandalu Resort & Spa offers numerous Asian restorative treatments and remedies including facials and floral baths.

Below: A guest enjoys a relaxing massage at the Alila resort near Ubud. This mountain resort is perched high up on the Sayan ridge.

Right: The Four Seasons Resort Bali at Jimbaran Bay is regularly voted as one of the world's top 10 luxury spa resorts.

Pages 106–106: The island of Bali is one of the world's most popular beach resort destinations and it's easy to see why from this idyllic stretch of shore.

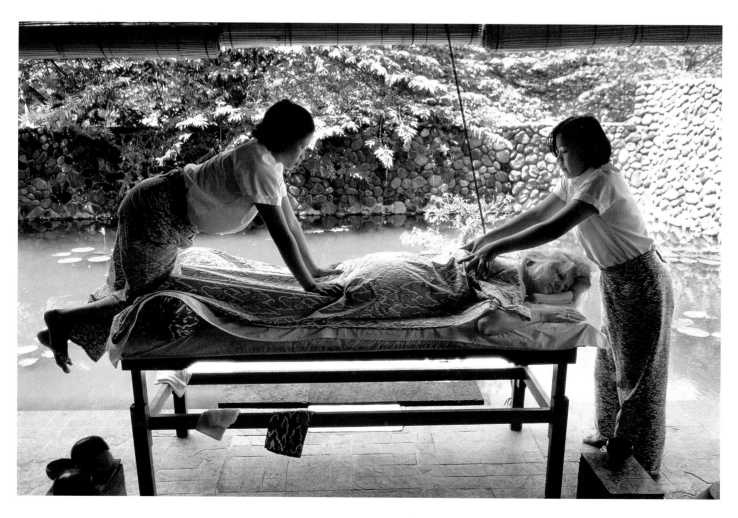

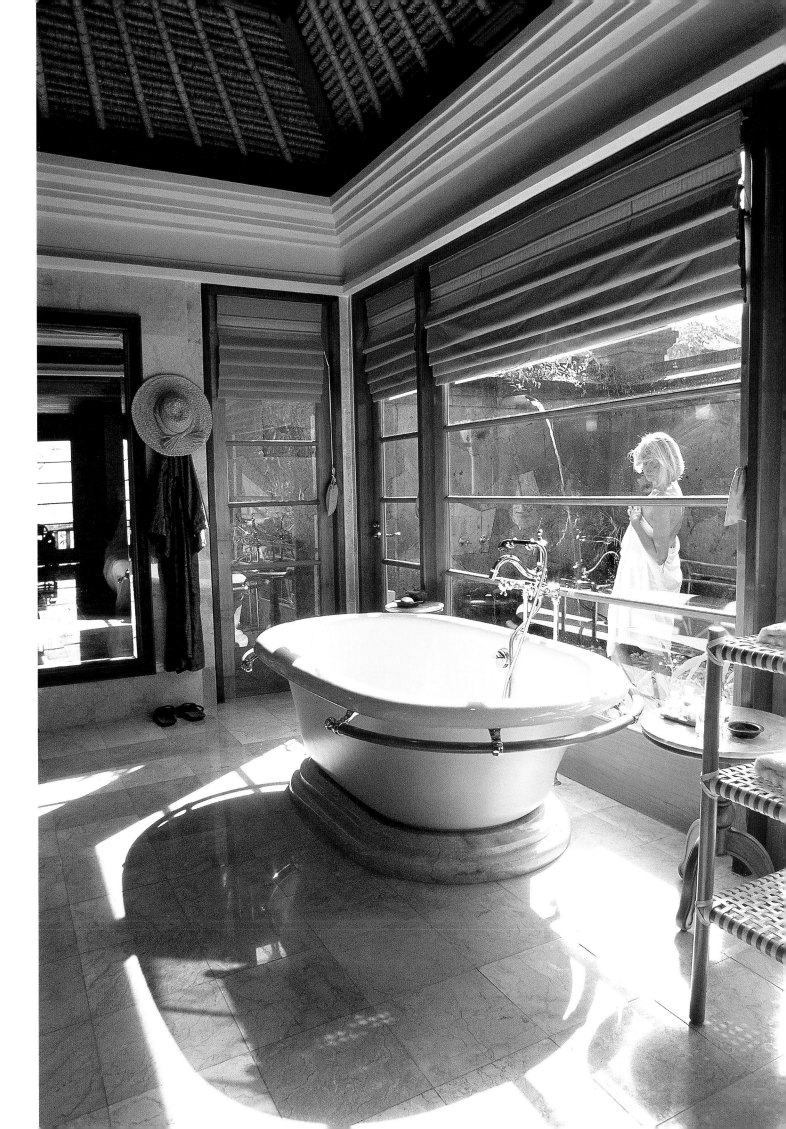

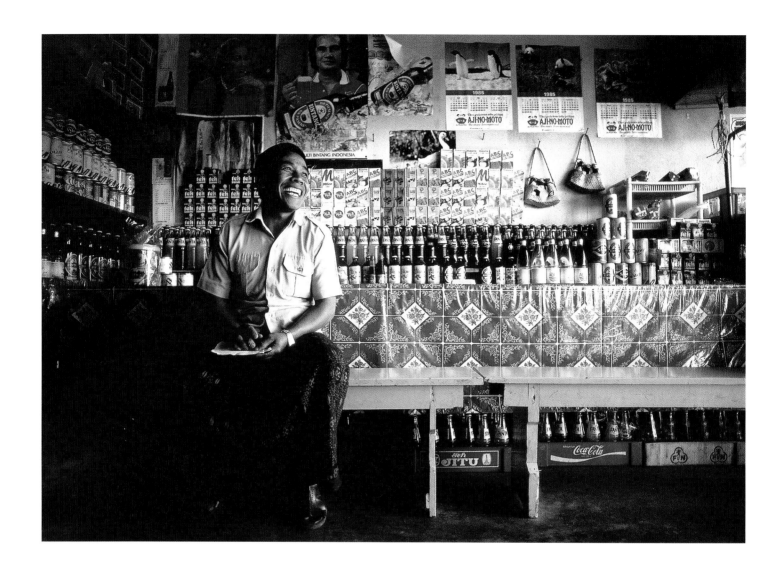

Above: A drinks stall owner enjoys a quiet moment at his *warung* before the start of the day.

Left: Restaurants catering to all tastes may be found on Bali. Cafe Wayan was established in 1977 in Ubud. It serves all types of food, including seafood, pasta and vegetarian dishes. Some, such as the Monkey Cafe, specialize in vegetarian cuisine.

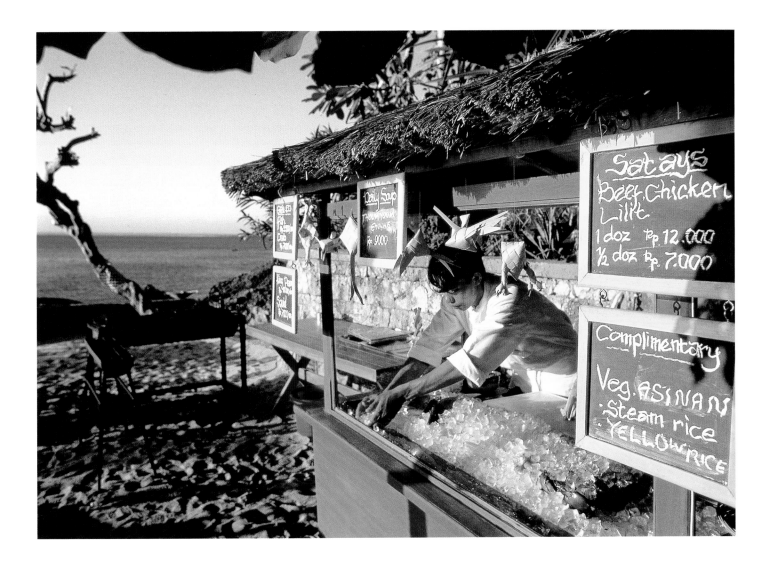

The menu board reads:

Satays
Beef.Chicken
Lilit
1 doz Rp.12.000
½ doz Rp.7.000

Complimentary
Veg.ASINAN
.Steam rice
.YELLOW RICE

Above and right: Sited on a bluff overlooking the Indian Ocean, The Ritz-Carlton Bali Resort & Spa boasts its own private beach.

Pages 110–111: A purple sunset descends on Candi Dasa, a popular tourist beach resort on the secluded eastern shore of Bali.

Page 112: Guests take in the spectacular sunset view by the pool of the Amandari resort.

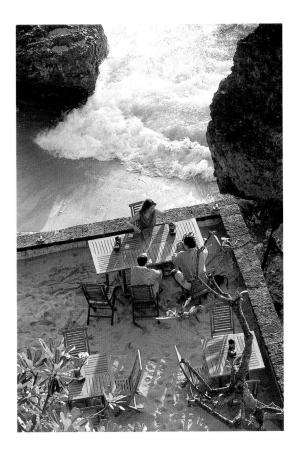

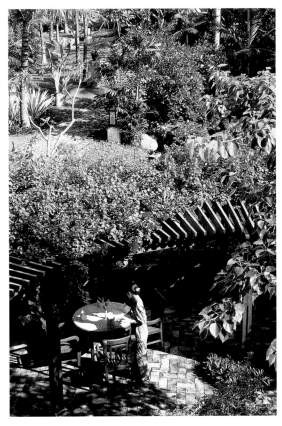

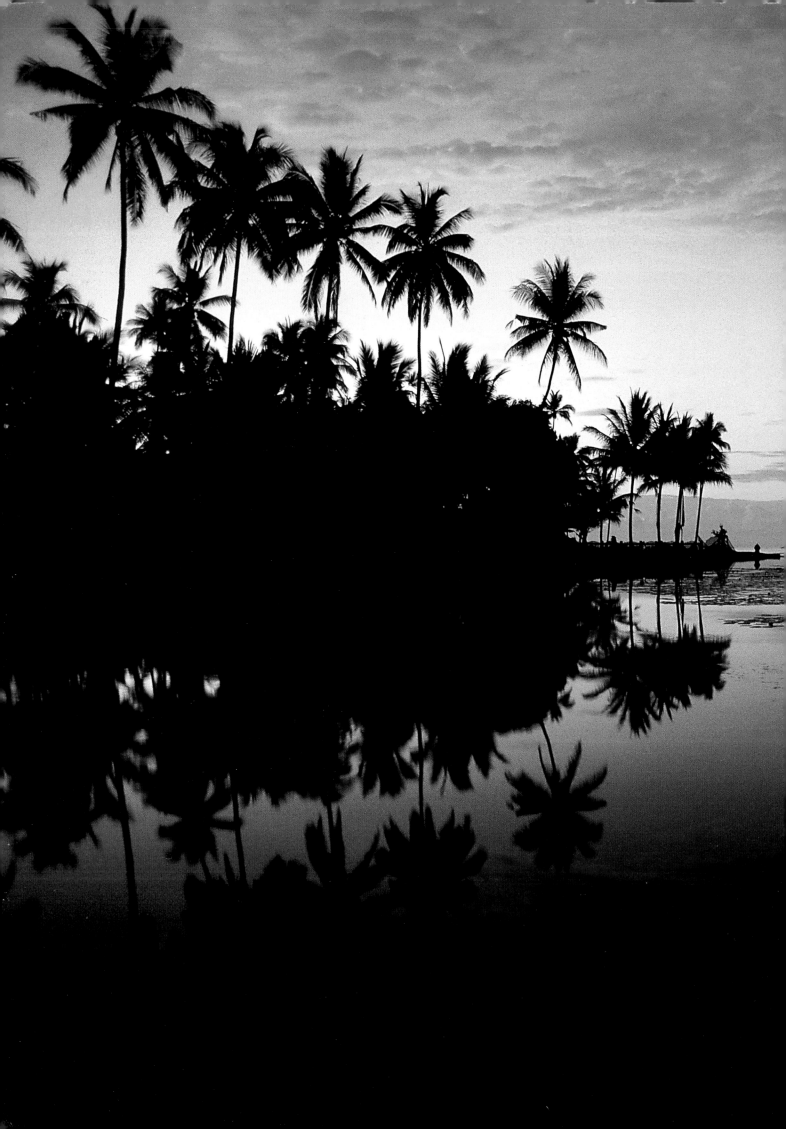